HAUNTED
GRANBURY

HAUNTED GRANBURY

BRANDY HERR

Published by Haunted America
A Division of The History Press
Charleston, SC 29403
www.historypress.net

Copyright © 2014 by Brandy Herr
All rights reserved

First published 2014

Manufactured in the United States

ISBN 978.1.62619.310.9

Library of Congress CIP data applied for.

CONTENTS

ACKNOWLEDGEMENTS

First off, I, of course, have to thank my mother, Coletta Henderson, for always being my biggest cheerleader and encouraging me to write, even long before I ever considered making a career of it.

Thank you to everyone who has helped us with making the Granbury Ghosts and Legends Tour a success: Chris "Boots" Hubbard for joining our team as a fantastic tour guide, Tony Procaccino with the Granbury Visitor's Center for always doing his best to promote our tours and any special events we hold, Patricia Shepard with the Granbury Resort Conference Center for helping to ensure that our events are a success, Charlie McIlvain for giving us the enthusiastic go-ahead to start the Granbury Ghosts and Legends Tour in the first place, the two anonymous women who first put the idea of starting a tour in our heads and the town of Granbury itself for embracing us and making us a part of the family.

Thank you to everyone who took the time to let me interview them about their stories for this book: Tonya Adams, Sydney Carder, Kay Collerain, Cheyenne Collins, Sheri Collins, Carol Cooper, Cherry Hanneman, Cindy Hyde, Mandy Jenkins, Brad Klinge, Chrystal Ramadan, Melinda Ray, Selena Roane, Miranda Scott, Deborah Carr Senger, Charlie Shearing, First Sergeant Gregory Stephens, Ginny-Rea Urban, Linda Wark, Melba White and Andre Wullaert.

Thank you to Richlon Merrill for taking the time to compile a disc of historic photos to get me started on my search.

ACKNOWLEDGEMENTS

Thank you to Mary Vinson for allowing me to use your beautiful angel picture for the back cover.

Thank you to Jessica Oakes for taking my author's photo.

Thank you to Laurel Pirkle for saving the day by providing me with your personal photo album of historic pictures to use in the book.

Thank you to Christen Thompson with The History Press for approaching me about writing this book.

I have to thank my husband, Matthew Herr, for maintaining his patience and understanding when I had to ignore him while getting this book completed.

And last but not least, I want to thank all my friends and family for encouraging me, for putting up with my endless Facebook posts (and even "liking" them!) and for making me realize just how fortunate I really am.

INTRODUCTION

Granbury, Texas. A bright, cheerful town with some dark, scary tales. The jewel of the Brazos. Where Texas history lives—so says the town slogan. Growing up in the slightly more urban area of the Dallas/Fort Worth Metroplex, I never dreamed that one day I would wind up living in a small town like Granbury. Nor did I ever dream that such a quaint tourist town could hold such history, secrets and stories from past residents who just do not want to leave.

I first arrived in Granbury with my mother in August 2009. Incidentally, the very night we moved in, driving through the historic downtown square to reach my aunt's house, *Ghost Lab* was investigating the Granbury Opera House for an episode to air at a later date on the Discovery Channel. The sight of its trailer parked on the square was the first to welcome us to the town of Granbury proper. We should have realized then what the future would hold.

My mother and I spent a few months working various food service jobs trying to make ends meet and quickly fell in love with the town of Granbury. The charming square and the friendly locals were swift in making us feel right at home. I wound up working as a server, along with my mother, at a restaurant that was located inside the Nutt House Hotel on the square at 119 East Bridge Street in 2010. It was rumored to be haunted, and our experiences inside the building only cemented our belief that the rumors were indeed facts.

Tourists would stop in for a bite to eat and then ask us if it was true that the building housed a few nonpaying guests. We would confirm and then

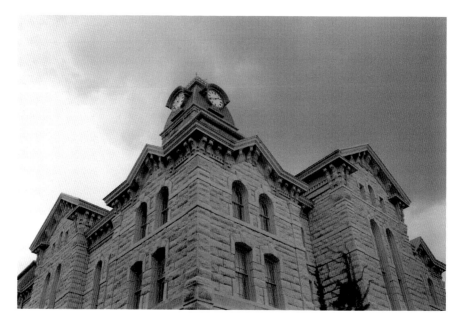

The Hood County Courthouse under a stormy sky. ©*Qiwoman01/Dreamstime Stock Photos &* *Stock Free Images.*

proceed to tell them our stories. The pinnacle moment came on one slow evening when we were chatting with a couple ladies who were sitting at the bar. As we told them about our ghostly encounters, one asked, "Does Granbury have a ghost tour?" It was as if a light bulb winked on above both of our heads. My mother and I thought simultaneously, "No, but it should!"

We began our research walking door to door on the square, asking shop owners and employees if they had experienced anything unusual. We had been on several ghost tours in other states in the past, so we had a basic idea of how one should be run. My mother is a Civil War reenactor, so we already had a wardrobe of period attire available that we could wear to enhance our tour guests' experience. We already knew of the locations of a few ghosts—the Granbury Opera House, of course, and a few others that will come to be mentioned in later chapters of this book—so we figured if we just got a few more stories, then that would give us enough to work with. What we found instead astounded us.

Almost every person we spoke with on the square that day had a story to tell us. You could almost see the relief in each person's eyes that he or she had someone with whom to share their experiences, to confirm that what had been seen and felt was real and not a symptom of a

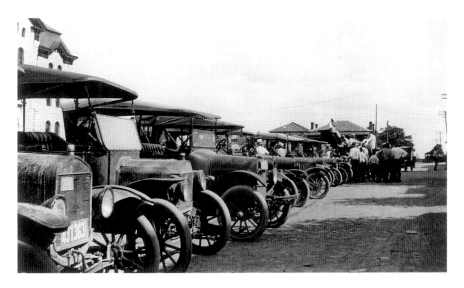

Granbury's downtown square has always been the place to be on a Saturday, as evidenced in this circa 1925 photo. *Courtesy of Laurel Pirkle.*

mental disturbance. We knew that Granbury was an old town and would therefore have a few interesting spirits who would want to linger, but we never realized just how many!

Later, we learned a possible explanation for why there is such a multitude of ghosts in Granbury. A ghost hunter once told us that limestone tends to act as a conductor of energy, holding energetic imprints of all the people who pass through and live within its walls. Buildings made up primarily of limestone tend to be more haunted simply because the energy of the spirits is still being held there. And what is the main building block of the buildings on Granbury's square? Limestone, of course!

The Granbury Ghosts and Legends Tour made its inaugural run on April 23, 2010. I was the original tour guide, leading guests from all over the country and the world as they delved into Granbury's darker side. We would joke that while you could go to a bar to enjoy Granbury's nightlife, you could come to us and experience its night-afterlife! Since then, we have added a second tour, conducted late at night at our historic city cemetery. Our tours have become an attraction that draws in visitors week after week to be spooked and scared.

Our spiritual residents do not cease to spook and scare our visitors, either. While some tours may be quiet, others will be quite active, giving guests the thrill—and even sometimes the evidence—they were hoping for. Ghost

Brandy Herr entertaining the crowd at the Granbury Ghosts and Legends Tour. *Author's collection.*

hunter and first sergeant Gregory Stephens with Research and Investigation of the Paranormal has complete confidence that ghosts join us on the tour. As he told me, "Why would they just be confined to the buildings? I always believe they walk among us."

In fact, we just may have had an actual ghost join us for a tour one evening. After a tour, one of our guests came up to me and revealed that she was a bit psychically sensitive to the unseen realm. She claimed that throughout the entire tour, a man had been following us, curious to hear my stories. She described him as a cowboy, which makes sense because we certainly have had our fair share of cowboys in Granbury throughout the years. She reassured me that this man was happy to be a part of the tour and that he enjoyed spending time with us, finding my stories interesting. I do always love to meet a fan!

We have had guests take strange pictures, from simple orbs to actual full-bodied apparitions. We have had unexplained noises and movement in windows. In a later chapter, we will be learning about a woman in a red dress who is often seen by children. One evening, a young girl and her brother

were guests on our tour. As we passed by the building, before I started my story, she said, "Ooh, are we going to talk about this building? Because my brother has seen a ghost in here!"

With a bemused smile, I asked her, "Oh really? What was the ghost wearing?"

She replied, "A long red dress."

I had intended only to humor the child, but instead I found myself enveloped in instant chills.

Ghosts also love playing with technology. On one tour, I looked over to notice some ladies in the group having a bit of trouble, huddled over a cellphone. My first thought, of course, was that they were either texting or playing a game. They then explained to me that they were having a difficult time fixing the phone, as the phone randomly started playing country music, using an application that none of them had ever used before, and therefore they could not figure out how to turn it off. I was slightly taken aback that the ghosts around us were so bored with my story that they would rather listen to music, but I shrugged it off as an interesting occurrence to give our tour guests a story to share.

In a similar vein, I had another tour guest share with me her experience. She, too, had her phone randomly start playing music while on our tour. She assured me that her phone was affixed with an alphanumeric passcode that made it impossible for anyone to accidentally bump it and start up any program. Interestingly, the album that began playing was called *We Don't Need to Whisper* by the band Angels and Airwaves. Whether you consider the album title or the name of the band itself, it most certainly seems that someone was wishing to convey a message that evening.

On our late-night cemetery tour, we have had guests whose flashlights have died shortly after the tour began, though they had just installed fully charged batteries. One of my stories was even met with the bloodcurdling scream of a phantom woman, but that was actually just the text message notification of one of our guests. However, I have yet to determine why anyone would willingly choose that sound as his or her ringtone.

Indeed, on our tour, sometimes the land of the living can be much scarier than the dead. Take, for instance, the moment that I discovered a large black snake curled behind the potted plant close to where I stood telling a story. I still managed to get through the story, though I kept one eye to the side as I spoke.

The scariest incident for me, however, had to be when I and the rest of the group almost became permanent fixtures of the tour. Mere seconds after we had crossed the street, a car went careening through a stop sign and past

us up the street, driving at least eighty miles per hour. We all looked on in amazement while I thought, "Wow, I guess someone needs to get somewhere in a hurry!"

Why would someone be traveling so fast down streets known to be heavy with pedestrian traffic? Our questions were quickly answered. Following the speedster were four police cars in hot pursuit! What we had originally thought was merely a rude driver was in actuality a high-speed police chase, and we were very nearly right smack in the middle of it.

To add another interesting twist to the story, after the tour, I called my aunt to tell her about the exciting happenings. Before I could open my mouth, however, she blurted out, "You will never guess what just happened! Four cop cars just chased a man into the backyard of my neighbor next door!" Leading these tours certainly keeps you on your toes.

Thanks to starting the Granbury Ghosts and Legends Tour, I have had the opportunity to experience things only found in movies and television shows. Due to our work on the tour, my mother and I were invited to join a paranormal research team and actually go out on real, live (pardon the pun) ghost hunts.

Research and Investigation of the Paranormal (RIP) arrived in town one weekend to investigate the Granbury Cemetery. Ironically, the group members had no previous notion that Granbury even had a ghost tour at the time. There are people unaware of the Granbury Ghosts and Legends Tour? Impossible! But sadly, it was true.

As they passed through the downtown square en route to the cemetery, they noticed us sitting on the bench next to our sign. They, of course, were intrigued by the two women in hoop skirts and became guests of the tour in hopes of learning additional historical and ghostly background they might be able to use on the investigation the next night. First Sergeant Gregory Stephens and James Leslie, the two co-founders of the group, became such immediate fans of the tour that they invited us to join them the next night to investigate the cemetery as honorary ghost hunters. From that initial investigation, we were later adopted into the team and have since had the pleasure of hunting for spirits with RIP in many of the buildings along Granbury's square and beyond.

The Granbury Ghosts and Legends Tour has opened up so many avenues for me since its inception. I have had the opportunity to meet wonderful people from all over the world and from all walks of life, from dyed-in-the-wool skeptics to full-on professional ghost hunters. Many of the ghost hunts I have personally attended will be featured in later chapters of this book.

This photo, taken in the 1960s, gives a small example of the historic buildings still found on Granbury's downtown square, though the businesses themselves have changed. *Courtesy of Laurel Pirkle.*

The rich history of Granbury continues to unveil itself before me, and its spiritual residents always have stories to tell. The following accounts are merely a small sample of the great multitude of otherworldly residents that live on or near Granbury's historic downtown square. Granbury may be where Texas history lives, but we prefer to say it's where Texas history never left.

CHAPTER 1

THE WILD EARLY DAYS
OF GRANBURY

Today, the town of Granbury is known for its quaint charm and historic atmosphere. The downtown square is lined with antique shops, boutiques, restaurants and other attractions one might expect to find in a haven for tourists. On the weekends, locals and visitors fill the area around the courthouse to attend family-friendly celebrations. Granbury is a lovely and safe place to call home. The atmosphere in the early days, however, was markedly different.

Perhaps a bit of clarification is needed before we continue on to the historical background in depth. Granbury was by no means a total hotbed of mayhem. The town was founded by upstanding individuals who believed in hard work and discipline. However, these individuals could not entirely contain the Wild West mentality that ran rampant in those days, and the history of Granbury reflects the spirit so often seen in popular westerns, with saloons, gunfights and outlaws.

Granbury is the seat of Hood County. The courthouse square that is the primary focus of this book was created in the 1860s, shortly after the Civil War, with the first courthouse located inside a sixteen- by sixteen-foot log cabin in the center of the square. A new courthouse was built in 1871, though it burned down in 1875 due to suspected arson. It is believed that some of the less honorable citizens of the town were eager to see the building destroyed, as that in turn destroyed the county's official land deeds and records, allowing for land titles to be forged.

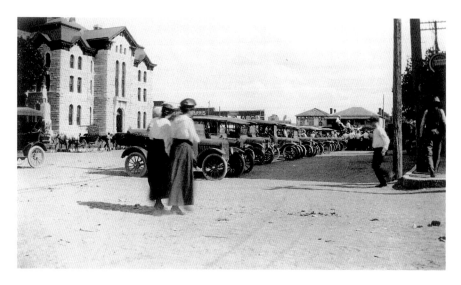

Looking south on Houston Street on Courthouse Square, circa 1925–26. *Courtesy of Laurel Pirkle.*

The courthouse was rebuilt in November of that same year. Throughout the years, the courthouse maintained some wear and tear, causing the walls to crack. The new courthouse, the one that stands today, was built in 1891 to provide a more solid location for Hood County's governing body. At the same time, the current Seth Thomas hand-wound clock tower was purchased for $1,400. The clock mechanism found in Granbury's tower is the same mechanism found in London's Big Ben, the most famous clock tower in the world.

On a side note, during the Ghosts and Legends Tours, when I mention the clock tower, I like to take that opportunity to invite a little audience participation and ask the visitors if they can guess where the other Seth Thomas clock tower is located. Oddly enough, the most common response I receive is the movie *Back to the Future!* Upon further inspection of the classic time travel film, it is clear that Granbury's clock tower and the one found in Marty McFly's hometown do not resemble each other in the slightest. Perhaps the visitors to Granbury's town square are so taken by the quaintness of still having a prominently displayed clock tower that their minds simply refer them to the only other small-town clock tower they can imagine, the clock that has entered our popular culture thanks to a time-traveling DeLorean.

The current location of the town site of Granbury almost never happened, but in the formation of Hood County, politics came into play. The final

The south and west sides of downtown square are pictured in the late 1800s with the courthouse on the left. *Courtesy of Laurel Pirkle.*

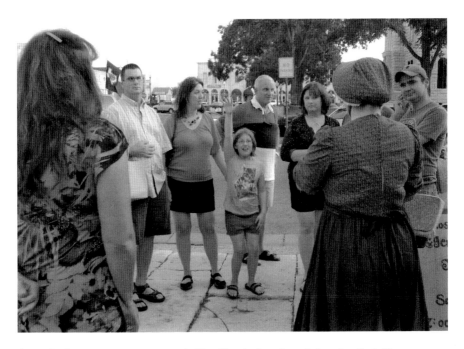

An excited young tour guest correctly identifies the location of the other Seth Thomas clock. *Author's collection.*

decision as to the location of Hood County's county seat was made by a small majority of voters to be a forty-acre land donation made by Thomas Lambert and Jesse and Jacob Nutt. Jesse Nutt was the son-in-law of Abel Landers, who served as the first judge of Hood County.

At the time that Hood County was formed, the area encompassed what is now nearby Somervell County as well. Because of this, most of the county's voters wanted the county seat to be located in a more centralized area, somewhere near Comanche Peak. However, because of Judge Landers's vested interest in seeing his son-in-law's land as the county seat, he did all he could to prevent the other area from winning out.

When the citizens voted in favor of approving the Comanche Peak area, Judge Landers closed the meeting early before the election proceedings could hit the record books. When it came time to decide whether or not to approve of Lambert's and the Nutt brothers' land, the citizens voted against the proposal. This did not deter Judge Landers in the slightest, however. He simply called for a re-vote, and finally, after several more votes, Judge Landers was victorious in receiving the vote of the majority. Thus, thanks to people in power with vested interests playing politics as usual, the town site of Granbury was developed where it currently stands today.

As historian Mary Kate Durham stated in her article "History of Granbury," written for the Hood County Genealogical Society, the early days of Granbury were "a rough and wild time." The shops that border the square today once housed as many as seven saloons at one time. The saloons created the atmosphere found today in *Bonanza* reruns or John Wayne movies.

The wild drunkenness came to a stop, however, when Granbury enacted a prohibition law in the early 1900s. This was set in motion by a visit from Carrie Nation, the famous prohibitionist and advocate of the temperance movement. She was most well known for her use of an axe, which she would bring down upon the beer kegs and bars, destroying them in a dramatic visual protest. While she left her axe at home for her visit to Granbury, she was still successful in organizing the women of the town into the Christian Women's Temperance League. This group worked together to eventually shut down the saloons and bring more respectable businesses to the downtown square.

However, it seems not everyone in town was eager to see prohibition take effect. One popular saloon, the Aston-Landers Saloon located on the north side of the square, reported to have sold every drop of liquor in the building and took in over $100 on the last night before prohibition

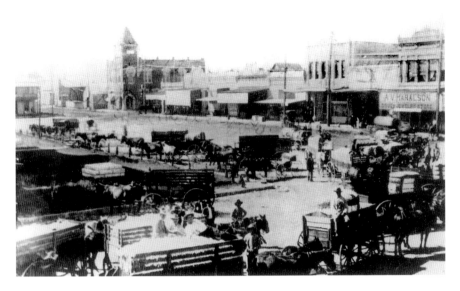

*Cotton farmers bringing cotton to the gin on the west side of the square in the early 1900s.
Courtesy of Laurel Pirkle.*

began. It was outside this same saloon that a duel occurred in 1901, badly injuring an innocent bystander.

One popular story centers on two infamous outlaws by the names of Clyde Barrow and Bonnie Parker, more widely known simply as Bonnie and Clyde. In the 1920s, the building at the southeast corner of the square located at 100 North Crockett Street served as a gas station. The architecture of the building today allows you to easily imagine the service station that was once there, with the large covered patio and angular corners.

The local legend tells us that Barrow and Parker traveled through Granbury on their way to their adventures, stopping at the corner gas station to fuel up their car and their bodies, and then boldly enjoyed a picnic lunch on the courthouse lawn. When they became recognized by some of the residents in town, they felt it wise to make a quick exit of the premises, thus eluding capture once again. Some even say that Parker's aunt owned a small café at the southwest corner of the square located at 102 North Houston Street, leading Parker herself to frequent the establishment.

With such a historic—and notorious—nature, is it any wonder that Granbury is home to a multitude of ghosts? In an area where lawlessness

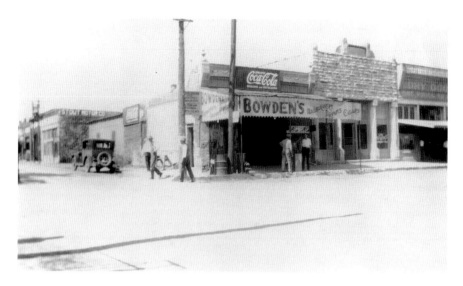

This building, pictured circa 1922, is believed to have housed a café run by Bonnie Parker's aunt. *Courtesy of Laurel Pirkle.*

had a tendency to prevail, it is certainly easy to see how the spirits here could be restless and full of unfinished business. Take a walk around Granbury's square, and if you look hard enough, you just might see the early residents who do not want to leave. The air is filled with the remnants of long-ago cowboys, saloon girls, outlaws and innocents caught in the middle.

CHAPTER 2
HELLO, MARY LOU

THE NUTT HOUSE HOTEL

The town of Granbury was founded, in part, by Nutts. No, that joke never gets old. Two blind brothers, Jesse and Jacob Nutt, established a log cabin mercantile store with a wagon yard in the back on the northeast corner of the square in 1866. That site at 119 East Bridge Street now belongs to the Nutt House Hotel, a building that was established in 1893, with the hotel itself opening in 1910. Though other sources list the opening of the hotel as 1919, earlier records show the date of 1910 to be correct.

Because the Nutt family numbered among the first Hood County settlers, arriving in the area in the 1850s, they had a considerable amount of land. It was thus that the two Nutt brothers, along with Thomas Lambert, were in the position to donate to Hood County the forty acres of land that would later become the county seat, the town of Granbury.

The J.F. and J. Nutt Building, as it is now known, has been occupied by three generations of the Nutt family. The building is a hand-hewn limestone structure built by Jim Warren. The simple yet elegant design near the roof and the solid stone makeup evoke sensations of an earlier time. The storefront on the first floor is composed mainly of windows, allowing for an open and welcoming atmosphere. Inside, employees greet their customers while standing at the massive wooden counter at the front that immediately brings to mind images of a Wild West saloon or old-fashioned ice cream parlor. Visitors can tread across the vintage wooden floor as they make their way through the first-floor shop and then head up the impressive staircase to reach the lodgings above. The seven hotel rooms upstairs are all lavishly

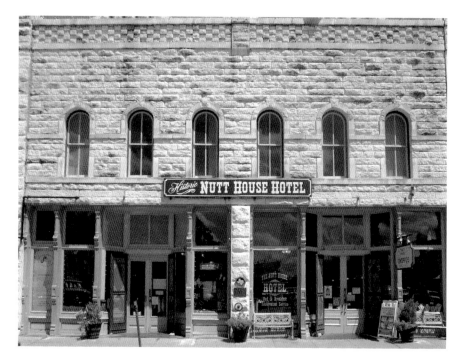

Exterior of the Nutt House Hotel. *Author's collection.*

adorned with antique furniture, old photos and other special touches, all while maintaining modern amenities and comfort.

Most famously, the building was home in the 1960s to a restaurant owned by Mary Lou Watkins, a direct descendant of David Lee Nutt, younger brother of Jesse and Jacob Nutt. Watkins was a stalwart champion of reestablishing the downtown square as a historic destination and of renovating the square to its former glory, beginning with restoring her own historic home and the Nutt House Hotel building. According to the 2012–13 Granbury Visitors Guide published by the *Hood County News*, "This restoration effort [set in motion by Watkins] provided inspiration and served as an impetus to building owners to restore or refurbish historic buildings on the square."

Mary Lou Watkins won countless awards for her efforts in ensuring Granbury's prosperity. Her work even resulted in the downtown square being recognized by the Texas Historical Commission and awarded the entire square itself the distinction of being the first historic downtown square in Texas included in the National Register of Historic Places. She was so well loved by the town that she is now immortalized in her own statue across the street from the Nutt House Hotel, wearing her characteristic period garb

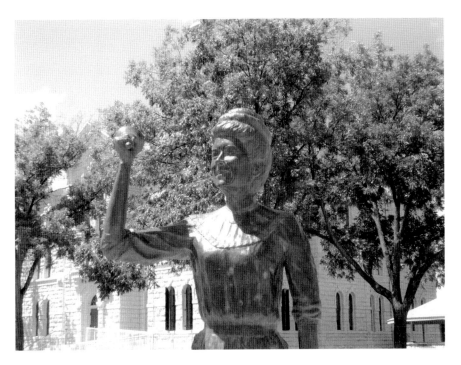

Statue of Mary Lou Watkins across the street from the Nutt House Hotel. *Author's collection.*

and ringing her iconic bell that would signal the beginning of dinnertime. Mary Lou Watkins joins Brigadier General Hiram Bronson Granbury as the only two to be commemorated in this fashion on the square, thus showing visitors and residents alike just how important Watkins was to this town.

Though she passed away from a long illness in 2001, many believe that Mary Lou Watkins loved her work at the Nutt House Hotel so much that she remains there to this day. Melinda Ray, current owner of the Nutt House Hotel, told me, "Mary Lou thinks she is still in charge!"

The Nutt House Hotel has become one of the most popular destinations for overnight travelers to Granbury, partly due to the rumors of its haunted nature.

As a matter of fact, don't forget it was actually the ghostly experiences that my mother and I encountered while working at a restaurant at the Nutt House Hotel in 2010 that inspired us to begin the Granbury Ghosts and Legends Tour, as I mentioned in the introduction to this book. I always like to say that, even after her death, Mary Lou Watkins is still doing all she can to see Granbury succeed as a tourist destination!

It seemed that something unexplained would occur almost on a daily basis as we served food and catered to our customers. We would often walk past

the sink to see the water running when no one had been by to turn it on. The restaurant featured an old wooden cabinet in the main dining room that held various extra decorations and other items needed for the restaurant, while at the same time doubling as a decoration itself. One cabinet door in particular liked to open on its own, forcing us to close it back with a call, "Okay, Mary Lou! We get it! We know you are here!"

On one slow evening, as the employees gathered in the front dining room, we all heard a giant slam coming from the kitchen, as if someone was storming through the back door, and that someone did not sound happy. We rushed as a group to the back of the restaurant, anxious and nervous to see who this intruder may be and just what he or she may want. Imagine our surprise when we discovered that the back door was still firmly shut tight and there was no evidence of anyone having been in the kitchen since we were last in there.

Mary Lou Watkins just could not seem to leave the back door alone. While several employees were in the kitchen at one time, they all were shocked to witness the back door suddenly slam open from the door frame. This was a very heavy door and would remain latched firmly in place until it was physically opened by hand. It would be next to impossible for the door to simply blow open in a heavy wind.

However, blow open it did. The door was flung open so hard that it startled the onlookers as it banged into the outside wall. The employees were forced to rush over and close it, while at the same time playfully scolding Watkins for scaring them. Imagine if a psychologist had walked into the restaurant at the time when all of the restaurant's employees were simultaneously talking to the air. What a field day he or she would have had!

My mother, Coletta Henderson, tended to have more run-ins with the spirit than I did, being a bit more sensitive to the unseen than I am. She would often catch a glimpse of a lady in a long dress and a bun walking up the stairs in the back dining room and across the upstairs landing. At first, she tried to convince herself that her eyes were merely playing tricks on her, a result of working too many hours on tired feet. However, further instances made her realize that there truly were unseen forces at play inside the Nutt House Hotel.

One evening, Coletta Henderson found herself in the back primary dining room assisting with the training of a new employee. It was later in the night, not far from closing time, and so they found themselves without customers to wait on, allowing for full concentration of the training materials.

Suddenly, the sound of a woman's laughter cut through the air. Henderson was the only female in the building at the time, so they knew the laughter

had to come from a guest and not an employee. Henderson and the new hire panicked, believing that a potential customer had entered the restaurant and they had not heard the opening of the front door.

This was unusual, as it was rather quiet in the restaurant at the time, and the front door did not generally open in a silent fashion, which allowed the employees to know when someone had entered the building. Nevertheless, they quickly raced to the front to greet the party before the guests decided to take their business elsewhere. However, when they reached the lobby, mere seconds after initially hearing the laugh, they found no one waiting for a table.

Mary Lou Watkins was not above playing the occasional joke on us while we worked. My mother and I found ourselves opening the restaurant one morning. We were the only two opening what food industry employees call the "front of the house," namely the portion of the restaurant where guests tend to sit and the waitstaff use as their milieu. The "back of the house" openers were busying themselves in the kitchen, quickly getting ready to cook and prepare food for the day.

We had a large party scheduled for that afternoon, and they had specially requested the upstairs landing area that was popular with private groups. My mother and I were both on the landing setting up for the party, rearranging the tables and chairs to accommodate the specified number of guests and preparing the table settings to look professional and welcoming. It was then that I realized we needed a second tablecloth to properly cover the dining surface. As I walked downstairs to the linen closet to retrieve the cloth, I heard my mother call down, "By the way, I have already unlocked it. You do not need to worry about taking the key!"

I was then quite surprised when I reached the linen closet only to find that the doorknob would not turn in my hand. Somehow, though none of the kitchen staff would have had any reason to enter the linen closet, the door had been locked since my mother had last opened it. I retrieved the key from behind the bar, unlocked the closet, gathered up the needed tablecloth and then locked the door again, jiggling the knob for good measure.

A short time later, as the hour for opening drew closer, I decided to fill the time by folding extra napkins. I asked my mother if she could bring me some more napkins from the linen closet so I could continue to fold without breaking stride. I advised her, "I locked the door back, so you will need to take the key."

She quickly returned with the napkins along with a puzzled look on her face, asking, "Are you absolutely sure you locked it back? It was unlocked when I got there!"

Mary Lou Watkins does not seem to remain only in the downstairs portion of the Nutt House Hotel building. On the upstairs floor, which houses the hotel rooms themselves, a great deal of unexplained phenomena has been reported. The most common room to display unusual activity is Room Four, appropriately named the Mary Lou Watkins Suite. Room Four is elegantly adorned in subtle tones, complete with solid wooden window shutters, antique chairs and a bed with a beautifully ornate headboard. It is a lovely room in which to spend a romantic evening or relaxing getaway.

In fact, my husband and I even spent our honeymoon in Room Four, specifically requesting the suite to see if we could witness any paranormal activity ourselves. While nothing out of the ordinary occurred in the room itself, one slightly unusual incident is worth noting. Though we had checked in earlier in the day and retrieved our key, the wedding, reception and other preparations for our upcoming trip kept us from retiring to the hotel until late in the evening.

We arrived at the hotel and reached the front door. I inserted the key into the lock and turned it, but nothing happened. The front door would not open. I tried jiggling the key, jiggling the knob and just in general jiggling myself, but nothing could get the door to budge. My new husband said, "Here, let me try."

I stepped aside so he could take a crack at the door, certain that he would have no better luck than I did. At this moment, Melinda Ray was hurrying through the store to open the door for us. Before she could reach the door, my husband rattled the key, and the door opened. Ray stood there puzzled as we entered the building.

"I was actually staying late to let you in!" she told us. "Something is messed up with the lock, and no one can get their keys to work."

My husband and I looked at each other and then back at her. "It must have worked somehow," I said. "He was able to open the door!"

"Let me try your key and see," she replied. She took our key, fiddled with the lock and then came back to us shortly after.

"I have no idea how you got in here!" she said. "Your key is not working any better than any others!"

I maintain the belief that Mary Lou Watkins knew we had a long day and allowed us into the building as her own form of a wedding gift.

It is not unusual for guests to hear voices when they are the only ones staying at the hotel. Their towels will have moved locations in the bathroom, they will hear footsteps outside the door to their room and sometimes the lights will turn themselves on and off. Guests in Room Four

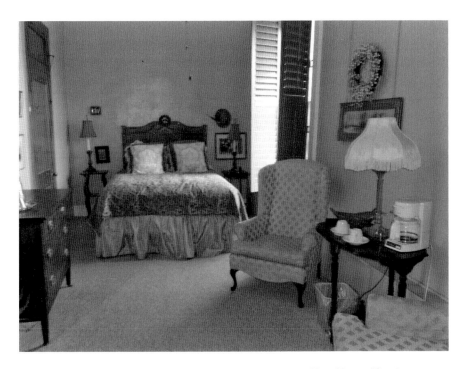

Interior of Room Four, the Mary Lou Watkins Suite, at the Nutt House Hotel. *Author's collection.*

have even described feeling a weight as an invisible presence joins them in the bed—perhaps an exhausted Mary Lou Watkins taking a break after tending to her company.

One harrowing account was given by two women who were staying in the Mary Lou Watkins Suite overnight. At around 4:30 a.m., one of the women was jolted awake from a deep sleep to the feeling of someone very firmly and urgently shaking her shoulder. She turned to her friend to ask her what was wrong, only to find that her friend was still soundly asleep beside her.

A bit shaken, she hurriedly woke her friend and told her what had just happened. Together, the ladies lay nervously on the bed, staring at the ceiling, wondering just who or what had caused this late-night intrusion. Suddenly, the temperature in the room dropped, causing the ladies to become ice cold. It was at this same moment that they began to hear knocking and banging on the walls and windows. The ladies quickly decided that whoever it was did not want them to get any more sleep that night, and they readily obliged!

Melinda Ray has noticed a rather odd occurrence herself in the upstairs lobby. As she goes about her day, she will often lower the wooden shutters

that cover the windows at the front of the building upstairs. Apparently, Mary Lou Watkins does not approve of this, as it obstructs her view. Later, as Ray will walk through the lobby, she will discover that the shutters have been pulled back up, even if Ray has been the only person in the building the whole time. If the shutters were in the up position and had been pulled down, Ray would simply blame it on gravity paired with a weakening pulley system. However, how do you explain shutters pulling themselves up?

As a guide of the Granbury Ghosts and Legends Tour, I have people sharing their ghost stories with me all the time. Because we begin our tours next to the Nutt House Hotel, many of these stories come straight from the hotel itself, as guests will exit the front door and walk directly toward me to share the odd experiences that have just occurred. One woman saw me sitting on the bench next to our Ghosts and Legends Tour sign, and her eyes lit up.

"Oh, I know this place is haunted!" she said while pointing at the hotel. "I was just in my hotel room, and someone knocked on the window!"

As all the hotel rooms are on the second story, it would be impossible for anyone to knock on a window of one of the rooms, unless that person were Paul Bunyan, who just so happens to be one of the few legends not associated with Granbury in any way.

On one weekend of tours, we were fortunate to play host to spiritual medium and certified paranormal investigator Deborah Carr Senger. She joined us on each of our Ghosts and Legends Tours, providing her insights and impressions to the astonished group. Senger made it a point to give her impressions first before learning any of the backstory behind the various buildings in an attempt to leave her findings untainted by previous knowledge.

Senger stayed at the Nutt House Hotel during her visit to Granbury, along with her cousin, Paula Schermerhorn, founder of the Fort Worth Ghost Tours. During her stay at the Nutt House Hotel, Senger witnessed a number of spirits, including one that could only be Mary Lou Watkins. Spirits were continuously moving up and down the stairs, including "a woman that was very determined, busy but so very happy to see us arrive," according to Senger.

The ghostly incidents at the Nutt House Hotel are not contained solely in Room Four. Two ladies told me of an unusual happening that they had experienced while staying in Room Two. As they left their room to partake in a bit of shopping around the square, one of the women deliberately locked the door, even double checking the knob to make sure it was firmly secured.

After their excursion around town, the ladies returned to the hotel for a bit of rest. Before reaching their room, they decided to take a quick peek in an unoccupied room across the hall to see how that particular room was

furnished. Their curiosity sated, they then returned to their room only to find the door pushing easily open when they had barely touched the key to the keyhole.

The staff at the Nutt House Hotel is top notch and would never leave a door unlocked after cleaning. Perhaps Mary Lou Watkins was sneaking a peek into their room at the same time that they themselves were admiring the adornments of the room across the hall?

For anyone who believes he or she would be too frightened to stay at the Nutt House Hotel, it is at this moment that I would like to point out that the presence of Mary Lou Watkins is quite friendly and accommodating. Melinda Ray assured me that she never feels uneasy inside the building and that the presence never strikes her as malevolent or threatening, instead always remaining benign at best and playful at worst. Sometimes Ray would even find previously closed wine bottles standing open, perhaps because Watkins decided it was time to host a party. Watkins always cherished her guests and continues to do so even if she must now share the hosting duties with other people. This was indicated during a visit by some paranormal investigators as well.

The ghost hunting group Research and Investigation of the Paranormal came to spend an evening at the Nutt House Hotel in hopes of making contact with Mary Lou Watkins. While this particular evening was not as active as others have been, group members did get a few interesting pieces of evidence. While standing in the bathroom downstairs, they easily heard steady footsteps coming from upstairs, directly above where they stood.

They also realized that Mary Lou Watkins likes to do what she can to make sure her guests are comfortable. As is customary on ghost hunting investigations, the air conditioning and the ceiling fans were shut down for the duration of the excursion. A common way to indicate that a spirit may be near you is the sudden change in temperature, most often in the form of an unexplained cold draft. It is essential to turn off any objects that could cause a draft, thus keeping the temperature regulated and evidence more consistent.

However, on more than one occasion throughout the night, as the ghost hunters would exit the hotel rooms and then later return, they would find the ceiling fans would be fully in operation, having been turned on by some other presence. It could simply be that Watkins knew how hot the hotel rooms could get in our typical Texas weather, and she wanted to make sure her guests enjoyed their stay to the fullest.

There remains the possibility as well that Mary Lou Watkins may not be the only spirit to reside at the Nutt House Hotel. During the ghost hunting

investigation, members of Research and Investigation of the Paranormal took numerous electronic voice phenomena (EVP) recordings. For those who are not as familiar with ghost hunting techniques, electronic voice phenomena is one of the most common ways that paranormal investigators retrieve evidence of a possible presence on the other side. Investigators place recording devices throughout the area under investigation and then simply ask questions or make statements that could provoke a response from a spirit in hopes that the recorder will catch it.

Throughout this particular investigation of the Nutt House Hotel, the group received only one clear EVP recording. This was caught in the recorder placed in the back room downstairs. The audio was that of a woman speaking Spanish, and it was so clear that they were actually able to translate it to, "Leave us alone."

Because Mary Lou Watkins was neither of Spanish-speaking descent nor the type to turn away her guests, we can only conclude that there are more spiritual residents of the Nutt House Hotel than we previously thought.

Thanks to the tireless determination of Mary Lou Watkins, Granbury is now firmly on the map of must-see destinations for tourists all over the

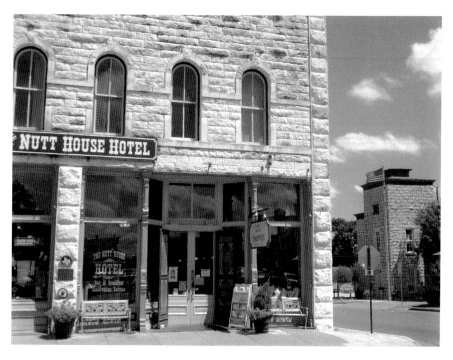

Nutt House Hotel with Historic Hood County Jail in the background. *Author's collection.*

world. Her work to restore Granbury's historic downtown square has gained the town the recognition it deserves. Many businesses on the square today, including the Granbury Ghosts and Legends Tour itself, would not exist if it were not for the legwork Watkins set in motion. She loved this town with a passion, and that passion shines through in the pride that Granbury residents now possess for their hometown.

If Mary Lou Watkins truly is the primary presence that is found at the Nutt House Hotel, then I personally owe her a deep debt of gratitude. Her past, and present, efforts to see Granbury succeed ensure that visitors to the town and to the Nutt House Hotel will remember and talk about their experiences for years to come. So come down and stay at the Nutt House Hotel and enjoy some of Mary Lou's old-fashioned southern hospitality—hospitality that will never die.

CHAPTER 3

LONELY JOE AND RESTLESS INMATES

THE HISTORIC HOOD COUNTY JAIL

There may not be anything creepier than an old haunted jail. The old haunted jail of Hood County is most certainly no exception. Now a museum, the walls inside the building still echo of the inmates who have passed through since it was built in 1885. They echo of the prisoners who were locked behind steel bars, desperate to regain their freedom, some of whom were never to walk out the front doors again.

The building we currently know as the Historic Hood County Jail is actually the second jail in Hood County. The first official Hood County Jail was built in 1873 as a log cabin building. While the tower in the second jail was built to accommodate hangings, the only official execution to ever take place in Hood County happened during the days of that first log cabin jail.

The man put to death was Nelson "Cooney" Mitchell. In the 1870s, the Mitchell family set out to help the Truitt family in settling their nearby home, with Cooney Mitchell carrying the note to the Truitts' land in the community of Mitchell Bend. According to Mitchell's own words, "[Truitt] purchased the farm on which he lived, together with corn, cattle, hogs, etc…I bought the indebtedness of Truitt—Truitt acknowledging the justice of the debt."

This resulted in a family dispute when Truitt failed to pay Mitchell for the loan, which ultimately led to Mitchell filing a lawsuit against Truitt. In March 1874, the lawsuit ruled in favor of the Truitt family. This ruling led to bitter feelings from the Mitchells, which came to a head on the ride back from the courthouse.

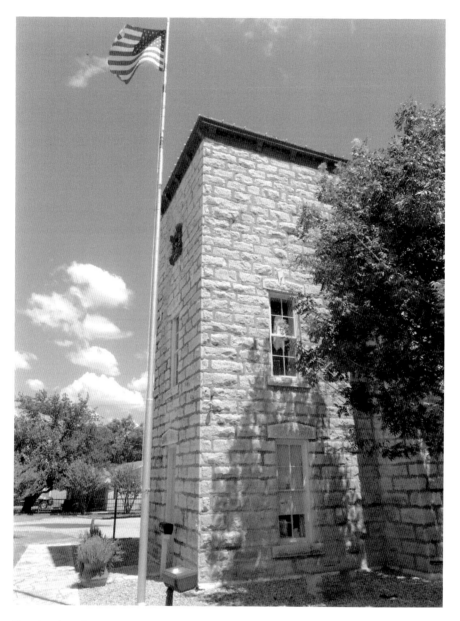

Exterior side of the Historic Hood County Jail. *Author's collection.*

Three of the Truitt sons began taunting Bill Mitchell and Mit Graves, a family friend of the Mitchells, while Cooney Mitchell reportedly encouraged his son and friend to defend themselves, calling out, "Give 'em hell, boys!"

Gunfire erupted between the two families, and though it is uncertain as to who shot first, one thing remains clear: when the smoke dissipated, two Truitt brothers lay dead and one lay wounded.

Though Cooney Mitchell may have in actuality been innocent of the crimes, the truth did little to assuage the townspeople, who cried out for justice. Mitchell was arrested for the shootings and held in the log cabin jail to wait for the carrying out of his sentence: death by hanging. While Mitchell remained in the jail, his son Jeff Mitchell attempted to aid his father by delivering a gun to help him escape and poison if he was unable to do so. However, before he could reach his father inside to supply him with the items, Jeff Mitchell was shot and killed by the guards of the prison.

Cooney Mitchell was hanged on October 9, 1875, at the age of eighty, the day after his son's attempted assistance, but not before crying out his final words of vengeance. He implored his sons to avenge his death by seeking out the "liars," the people he perceived to be the ones behind his ultimate undoing.

Eleven years after Mitchell's execution, his revenge was finally realized. While James Truitt was spending time with his wife and children in the

One possibility for Granbury's legendary "Hanging Tree" across from Granbury Cemetery, though others believe another tree was used. *Author's collection.*

comfort of his home, a bullet pierced the window of his house, killing him where he sat. Cooney Mitchell's son Billy was arrested in 1907 in New Mexico and convicted of Truitt's murder. Knowing that things did not end well for Mitchells in prison, however, Billy Mitchell wound up escaping from Huntsville and was never captured again.

On this backdrop of lawlessness, the second Hood County Jail was built. The late Victorian-style two-story main building is encased in stone with an imposing tower looming in the front. Situated just off the main downtown square, the historic jail is nestled across the street from the Nutt House Hotel. The caretakers of the museum even maintain a sense of humor about their haunted nature. In the upstairs window of the main front section, visitors are often delighted when they discover the friendly little ghost dangling there to greet them.

This jail has been the site of attempted escapes and even a few suicides. Inmates were imprisoned in this new building from 1885 until 1978, when a new, more modern center was built. Looking at the jail now, it is quite difficult to believe that it still held inmates as recently as the late 1970s. One guest of the Ghosts and Legends Tour even told me that he had at one time spent a few days inside the jail involuntarily. He admitted that the jail certainly did its job; the building was so creepy and inhospitable that he immediately turned his life around to avoid ever having to go back there.

Perhaps it is not merely the atmosphere that gives inmates and visitors a distinct sense of the creeps. Perhaps it is the inmates and visitors who have never left that really cause the skin to crawl. The most popular rendition of the ghost (one of many, to be sure) that haunts the historic jail is that of lonely Joe.

Bobbie Jordan wrote an article for the *Hood County News* detailing her supernatural experiences inside the jail during her tenure as the director of the Granbury Chamber of Commerce, which used the building before it became established as a museum. She found herself inside the building quite a lot, and she never could shake the eerie sensation she received from the building, especially in the upstairs jail cells.

The cells are truly dreary, and the misery of the many inmates incarcerated within the cell walls throughout the years can still be felt today. Even the staircase itself is enough to invoke palpitations in the faint of heart. The old metal stairs reach to the top floor in such a steep manner that you have no choice but to clutch the metal handrail in the hope that you do not make a wrong step and are then sent hurtling backward to the floor below. As I overheard one visitor to the Historic Hood County Jail Museum say, "Can

you imagine having to get a prisoner who did not want to be put in jail up those stairs?"

Bobbie Jordan vowed never to go upstairs alone unless it was absolutely necessary, and even then, as she put it, "I could not get down fast enough."

As she worked in the office on the first floor, Jordan often heard noises on the staircase as if the ghost was coming down to join her. She could sense his presence as he made his way slowly down the stairs, across the floor and into the second office, ultimately settling down in his preferred corner. He always settled in this same corner, as if this was the area where he remained the most comfortable. She knew he was there and could feel his presence near her, "almost like I could see him, but I never did." Somehow, she just knew.

Jordan was not the only person to sense an otherworldly spirit inside the Historic Hood County Jail. At one point, the chamber ambassadors were hosting tours for guests to experience this historic building. While Jordan worked, a guide took a group upstairs for the tour.

The tour was short-lived, however. Something upstairs had other plans. The guide immediately spun around and walked right back down the stairs, leaving her group bewildered and completely alone at the top of the staircase, now with no host to guide them. She sat down near Jordan, not speaking, all the while with a strange look on her face. Finally, Jordan felt compelled to ask if the guide was OK, hoping to elicit a response, any response. The guide finally replied, "There's something up there, and I'm not going back!"

No further elaboration was forthcoming, so what exactly the woman saw or felt up there in the dark jail cells remains a mystery.

There was one incident in particular that left Jordan's nerves rattled. The ghost of the jail appeared to share some sort of relationship with Jordan; he felt close to her, as he would keep her company while she worked. One evening, the spirit took this closeness to a whole new level. Jordan sat at her typewriter in her office, working furiously into the late hours of the night in the hope of meeting her deadline. Unfortunately for her colleagues, the deadline would have to wait.

While she sat hunched over the typewriter, determined to complete her work, a presence entered the room. He traveled slowly across the room to the unsuspecting Jordan, moving closer and closer to her work station. Finally, as he reached her, the spirit joined her at her desk, ultimately sitting in her lap. She recalls, "It was as if a thick, misty cloud enveloped my entire body."

Startled by the sudden and intense realization that she was not alone, even in her own chair, Jordan stifled a scream and sprinted for the door, the

completion of her work now the furthest thing from her mind. In fact, she was in such a hurry to reach the safety of the outside, she left her shoes behind in the office and found herself racing home in nothing but her stockings!

The possible identity of the spirit who vexed Bobbie Jordan inside the Hood County Jail was revealed in the mid-1980s. Granbury became host to a U.S. Bass organizational tournament, and the wives of the fishermen needed to fill the time while their husbands were reeling in their catches. The ladies were fascinated over the possibility of a haunting at the jail, and they asked Jordan if they might attempt to make a communication with him.

It just so happened that one of the members of this group was an "automatic writer," a person who could relate what the spirits were saying by writing down what was being psychically transmitted to her. Through this exercise, the group and Jordan were reassured by the ghost that he was harmless. It was discovered that his name is Joe, and he is a Native American who became separated from his tribe as they had been wandering through this area.

The ladies then asked if Joe might come downstairs so he could spend time with them in proximity. He immediately obliged, and as his presence filled the room, "everyone in the room felt it and knew he was there," according to Jordan. From this experiment, the ladies concluded that Joe is merely a lonely spirit who misses his tribe and is eager to seek out the companionship of anyone willing to indulge him.

The lonely, restless spirit of Joe may not be the only spirit to reside inside the Historic Hood County Jail. Jordan herself was slightly skeptical of the findings by this group of ladies. She maintained that she always had the sensation of the ghost wearing a khaki shirt and pants with a white Stetson hat perched on top of his head, which would be more in line possibly with a sheriff, not a Native American. Perhaps the ghost that communicated with these would-be ghost hunters was not, in fact, the same ghost that Jordan had experienced herself.

Indeed, there might even exist a bitter presence inside the jail as well. Throughout the years, the Historic Hood County Jail has been quite popular with paranormal research groups, often playing host to ghost hunters every few weeks. One such group run by Chrystal Ramadan frequents the jail in its search for otherworldly evidence, though at one point it may have led to personal trouble in Ramadan's life.

Chrystal Ramadan believes that one spirit living inside the jail is that of a former inmate named Stephen. She came to this conclusion after finding

among the multitude of graffiti from past inmates covering the cell walls a poem taking up a large portion of the wall. This poem reads:

> *In the silence of a prison cell,*
> *Your thoughts of the events that's led you here come and go*
> *And you ask yourself why!*
> *Only then do you realize that the course of history can't be changed, only sidetracked.*
> *For your destiny is forever in forward motion.*
> *So let your time here be short; Your thoughts long lived; And Remembered.*
>
> *Stephen Lee*
> *Alias The Poet 9-26-78*

Ramadan found herself fascinated with the poem and read it out loud. This reading stirred something up within the cell walls, and the air shifted to a more tumultuous atmosphere. The group then received an electronic voice phenomenon recording of an old man saying, "Oh, shut up!"

Perhaps it was merely a critic who has more of a penchant for prose than for poetry. However, upon engaging the popular "flashlight trick," in which ghost hunters request that the spirit turn a flashlight on in answer to their questions, in response to the question, "Is your name Stephen?" the flashlight suddenly turned on, shining brightly to illuminate the investigators' curiosities.

Stephen, or someone claiming to be Stephen, continued to become annoyed by the presence of the ghost hunters. Ramadan decided to prod a little further to see if she could catch some more compelling evidence of his existence. She called out defiantly, "I don't believe you are here!"

Stephen accepted the challenge. The group immediately heard banging along the cell walls in response. One of the ghost hunters may even have been attacked; a young girl joining the investigators received a painful scratch from unseen hands. Ramadan, angry that the ghost would take his aggression out on an innocent young girl, cried out, "You are a jerk for scratching this poor girl!"

That was the last straw for the spirit. It was at this moment that he decided to make Ramadan his next target.

After a ghost hunting investigation, it is always important to say a prayer based on your personal faith. At the very least, every ghost hunter needs to make some sort of protective statement, letting the ghosts know that they must remain in this area and they are not allowed to come home with the investigator. This, however, does not necessarily work 100 percent of the time.

The ghost that scratched the young girl, the same one that either penned the poem or otherwise had aversion to it, was determined to make a jailbreak.

The energy of the spirit attached itself to Chrystal Ramadan and traveled back with her to her home. Shortly after the investigation, Ramadan found herself strangely sick, falling prey to the same unexplainable illness that another in her same ghost hunting group experienced at the same time.

The trouble did not end there. Ramadan found her relationships with other people going downhill and other major aspects of her life wrapped

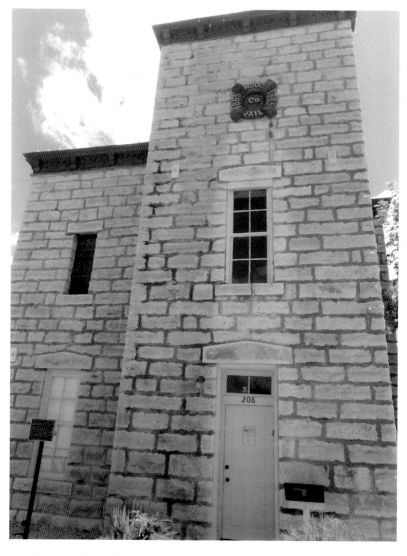

Exterior front of the Historic Hood County Jail. This tall front section was built to accommodate hangings, but it was never used. *Author's collection.*

in turmoil. She traces each one of her hardships back to that evening when she ended up taunting a spirit who was not in the mood for jokes. Ramadan has since gotten her life back in order, and the spirit has moved on from her home, but not before teaching her a difficult lesson. Sometimes, when you mess with the spirits, they like to mess back.

Luckily for me and my paranormal investigative team, our own personal investigation of the Historic Hood County Jail was slightly more benign. While we managed to find some compelling evidence, we were able to do so unscathed, not experiencing any potential danger. Our evidence came in the form of two clear audio recordings. One, taken in the main cell, featured a man audibly groaning in the background. This is the groan of a miserable person, almost taking on a growl-like quality. Clearly, this person deeply regretted the actions that led to his becoming incarcerated in this desolate place.

Another audio recording captured a woman screaming unintelligibly, followed by a loud bang as if a cell door had suddenly slammed shut. Upon further inspection of the recording, if you listen very closely, it sounds like the woman is saying, "Leave!"

I certainly hope she was not talking to us, as we most definitely did not mean her any harm by our presence that evening. Was this possibly a sheriff's frustrated wife, who had the job of cooking for the inmates who lived above her as she and her family occupied the bottom floor? Might it have been instead a former female inmate, driven mad from her confinement in such a thoroughly frightening cell? The secrets of the jail still remain hidden within the walls, and no answer will soon be revealed.

D&S Paranormal is another ghost hunting group that frequents the Historic Hood County Jail. Sheri Collins, one of the group's co-founders, shared with me one of the experiences that caused the jail to become her favorite place to investigate. Her group was using an old set of keys that were originally used by the jailers of Hood County. While Deegan Hodges, the other co-founder of the group, stood inside the main jail cell holding the keys, an unusual thing happened.

Standing apart from the rest of the group, Hodges suddenly felt something touch his head, and shortly after, the keys began to sway in his hand. Collins described it, saying, "It was like they were begging us to use [the keys] to communicate."

The group happily obliged and began questioning the spirits while Hodges held the keys dangling loosely from one finger. In response to the line of questions, the keys would begin swaying on their own. However, any time

Collins would say, "Stop," the keys automatically ceased all movement, as if they were being held tightly by an unseen hand.

Andre Wullaert of North Texas Ghost Society has made contact with a few other inmates. Some of the audio recordings yielded not just first names but last names as well. The group checked these names against a book containing the names of the past inmates. One name from the recording was identified in the book as an inmate who had poisoned himself during his incarceration.

Curiously, another name indicated in the recordings popped up in the book as a man who had been an inmate of the Hood County Jail for only four days. Why someone would want to remain in spirit at a jail where they only spent four days remains a mystery.

Wullaert told me that he often hears scratching at the bars in the main jail cells, as if someone is slowly running their fingernails over the metal. Any time Wullaert comments on hearing these noises, they abruptly cease, only to begin again once the group members return to the cells later in the evening.

One of the other members of North Texas Ghost Society once felt something touch the back of his neck, an incident that occurred simultaneously with the appearance of a ball of light appearing on the camera and moving toward the man.

Wullaert told me that the great deal of paranormal activity inside the Historic Hood County Jail has become so well established that his group now uses the building more as an experimental facility. Rather than simply trying to find out if spirits are present, they instead use the Hood County Jail to try and enhance their means of communicating with the spirits, thus allowing them to better innovate for their future ghost hunting investigations.

A truly unnerving experience occurred one evening as a guest was staying at the Nutt House Hotel across the street. The guest told Nutt House Hotel owner Melinda Ray about her strange encounter. One evening, this lady was staying in Room Seven, just down the hall from Room Four, with its window situated almost directly across the street from the jail. Late at night, this woman found herself waking suddenly for no discernible reason.

As she lay in bed, trying to once again fall asleep, she became restless. She made her way to the window to enjoy viewing the calm of the street below. However, what she witnessed instead caused quite a lot of astonishment. On the street, just down from the Historic Hood County Jail, walked a man. As he strolled, the lady could make out that he was dressed all in brown, from his jacket to his pants, and a "flashy-looking" hat adorned his head.

At first glance, this man could have simply been mistaken for an eccentric gentleman who happened to enjoy a late-night stroll dressed in fine, period

attire. However, as the woman followed his movements with her gaze, she was shocked to discover that as the man reached the building of the jail itself, he disappeared right before her eyes. Shaken from what she had just seen, she also managed to note that at the exact location where the gentleman stroller disappeared, there appeared to be an ornate cannon resting on the ground. Further inspection of the grounds of the jail the next day revealed to her that, of course, there is no cannon on display near the jail.

Upon recounting this experience to a friend of hers, who is a student of the Civil War and the armaments of the war in particular, he began showing her various pictures of antique cannons in the hope that it would jog her memory. She pointed to one picture and enthusiastically cried out, "That one! That is the one I saw!"

Her friend revealed to her that that cannon is in fact a very old cannon, used by the Confederate army during the Civil War. Could it have been a manifestation of a Confederate soldier that this woman saw from her vantage point at the Nutt House Hotel window?

Spiritual medium Deborah Carr Senger received an unusual sensation at the Historic Hood County Jail as she joined us on our Ghosts and Legends Tours one weekend. "As we departed and headed towards the jail," Senger recounted, "I felt extreme pain in my stomach as if many had died of disease or maybe just bad food. The jail, of course, would bring feelings of sadness and despair, but I felt the presence of a woman that lived there and was known for her cooking."

Nothing has ever been recorded about a possible food poisoning or any other outbreak of illness associated with the jail, but this theory certainly brings an additional possibility as to why there may be so many restless spirits surrounding that area.

Today, as a working museum and home to numerous artifacts from around Hood County, the Historic Hood County Jail is a popular tourist destination. Visitors can enjoy learning about the history of the area while marveling at the thought of how anyone could be able to spend even a night locked up behind the dreary cell bars. Inside the upstairs floor of the jail, guests will not only see the iron cage in the main room, which could house up to eight inmates at a time, but they can also enhance their sense of claustrophobia in the single concrete room with only a few pipes built into the wall for ventilation that was used primarily for "the women and the insane," according to the Hood County Historical Society's website. A stroll through the building makes it easy to imagine the possibility that some former residents of the jail have become so embittered that they just cannot seem to leave. What was once a prison in life remains a prison in death.

CHAPTER 4
LITTLE AUDREY AT HOME

THE LANGDON CENTER

Without a doubt, my favorite haunted location in Granbury is the Langdon Center on Pearl Street. Initially intrigued by the story as we began doing our research for the Ghosts and Legends Tour, my personal experiences inside the house never cease to amaze me, and it makes me want to hurry back to visit again every time I leave.

The beautiful white house at 307 West Pearl Street, about a block down from Granbury's square, is also known as the Gordon House. The two-story building with the large, covered front porch and airy bay windows flanking either side of the front door inspires the imagination to recall the age of southern gentility. Built in 1882, this house was home to Alonzo Peyton Gordon and his family. Gordon moved to Granbury from Georgia in 1871 and took a job teaching school. He then operated a prosperous mercantile store and saloon on the square located at 137 East Pearl Street. In 1898, Gordon was elected to the Texas legislature to serve this district.

A prominent man in town, it is no wonder some people believe that Alonzo Peyton Gordon loved Granbury so much that he did not want to leave. Employees and visitors of the Langdon Center, now operating as an art museum and cultural center, have had numerous encounters with otherworldly spirits over the years. Gordon himself has even been spotted by people from time to time, though never in a straight visual. A person will catch movement out of the corner of her eye and recognize the source of that movement as a man wearing a long-sleeved white blouse and black slacks. However, when she turns around to greet the stranger, the man is nowhere to be found.

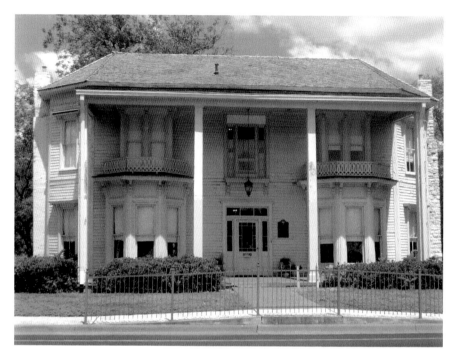

Exterior front of the Langdon Center, otherwise known as the Gordon House. *Author's collection.*

An employee will sometimes be upstairs working in the office when he hears the front door open and close, followed by footsteps on the staircase. As he sits and waits to see who is ascending the stairs to visit him, he finds himself waiting indefinitely. The footsteps never reach past the second or third stair, and they are never heard retreating back out the front door. In a house as old as this one, the door and floors tend to remain quite creaky, thus making it impossible for anyone to open the door and move along the staircase without easily being heard.

The doorbell has also been known to ring from time to time, as if a visitor is coming to call. However, the doorbell has long since been broken, and no physical being is able to render even the slightest chime from its mechanism. Is it a rogue satellite signal that is triggering the bell, or is the bell actually being pressed by unseen fingers?

As active as Alonzo Gordon may be in his own home, it is his granddaughter Audrey who really steals the show. Audrey Maurine Gordon was born in 1902, the daughter of A.P. Gordon's son, Charles Henry Gordon. Audrey tragically passed away in 1908 at the terribly young age of five. Though her

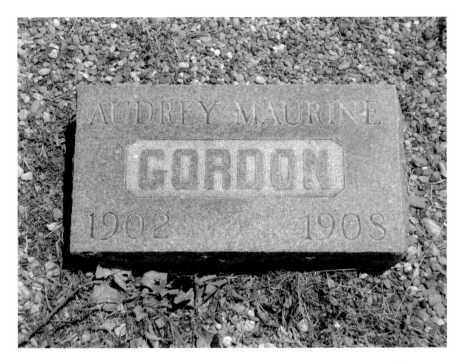

The headstone of Audrey Maurine Gordon at the Gordon family plot inside the Granbury Cemetery. *Author's collection.*

cause of death is unknown, one particular guest on the Ghosts and Legends Tour may have developed a theory.

Spiritual medium Deborah Carr Senger received some very distinct impressions on her visit to the Langdon Center. Upon reaching the house, Senger was struck by a strong wave of emotion. "There was foul play," Senger said. "He killed her and it was covered up, not only by him but several of his business associates. It was a profound feeling of injustice, yet the little girl was happy playing the piano, giggling and waving at the crowd."

It is unclear as to the identity of the man Senger envisioned. Alonzo Gordon knew just about everyone in town due to his business and political status; it could have been anybody. One thing is certain, however. Be it from foul play, illness or even just an accident, little Audrey's life was tragically cut short, and her spirit now remains inside the Langdon Center. Audrey must love the old Gordon home, because she has never wanted to leave.

Audrey seems to be drawn mostly to the children and teenagers who enter the building, though she has an affinity for females in general, perhaps seeing them as mother figures. A group of children between the ages of

twelve and fifteen had been taking weekly music lessons at the Langdon Center for a while. Audrey loved these children and loved the idea of having other people relatively close to her age in the house with whom she could play. The children would often tell stories of hearing a small girl laughing from the other room. Sometimes, the children would find themselves locked in or out of a room after Audrey decided to pull a prank on them. They did not feel frightened of her; they knew she was not trying to trap them but was merely making mischief.

Enter our group: Research and Investigation of the Paranormal. Little ghost girls are always intriguing and a bit scary. Think of any movies about ghosts that you may have seen. Which scenes were most likely to cause the hair on the back of your neck to stand up? The scenes involving ghost children, of course. There is just something about innocent young girls transformed into ghostly apparitions that gives countless fans of the paranormal the heebie-jeebies. So naturally, once we learned of the presence of a ghost child inside the Langdon Center, there was no question. We had to investigate it.

Research and Investigation of the Paranormal has conducted two investigations inside the Langdon Center so far. From each ghost hunt, we have received astounding evidence that leaves no doubt as to the ghostly presences inside the home. Audrey, in particular, loves interacting with her guests, constantly performing for the camera. We have caught countless audio recordings from Audrey, as well as from other possible spirits residing inside the house.

Audrey seems to be particularly enchanted with music. Seeing as how she loved playing with the children who were taking music lessons, it seemed natural to assume she loved music in general. To test this theory, we brought a guitar with us to the first investigation to see if it might draw her out. This guitar is known to ghost hunters as a "trigger object," an object used by the investigator to hopefully stir up feelings and memories in the spirits, feelings and memories strong enough to encourage the ghosts to reveal themselves.

On any of our investigations, the hunt is conducted through "sweeps." A sweep is when a small group of two to four members is sent into the building to try to provoke the spirits, while the rest of the group stays back in the control room to watch the monitors, take a break or just bide their time until they get a chance to enter the building. It would be a huge folly to allow the entire group of twenty or more ghost hunters to enter the building at one time. Too many people with the ability to make noise in the same area at the same time will greatly compromise any findings you may get, so it is to the best advantage to keep the groups small and cycle them throughout the night.

That being said, we brought the guitar and entered the Langdon Center to perform the group's first-ever "music sweep" at a ghost hunt. The group consisted of Tyler Solomon; Brandon Stephens, son of RIP co-founder First Sergeant Gregory Stephens; and me. Brandon Stephens began to play the piano, while Solomon and I joined in, singing and having fun, trying to create a lighthearted atmosphere that would welcome a child. It worked. Audrey was having so much fun at our little party that she did not want it to end. At one point, Stephens stopped playing the guitar to hand Solomon a flashlight. At this exact moment, upon later review of the evidence, a stellar piece of audio evidence was recorded. As Stephens leaned across the chair toward Solomon, a little girl's voice pleaded, "Don't stop playing, Brandon!"

On the second investigation, Gregory Stephens found himself playing the guitar. Once again, the music enthralled Audrey, drawing her spirit to the soothing tunes. As Stephens played around with the guitar, each time he stopped the music, Audrey would implore him to play some more.

"Can you do it again?" was heard twice from the voice of an unseen child.

When Stephens asked Audrey if she enjoyed listening to the piano, he was met in response with a clear, high-pitched, "Yes!"

Music may soothe the savage beast, but it certainly excites the small child.

My mother, Coletta Henderson, managed to engage with Audrey personally. On her first sweep during the first investigation, Henderson, along with Gregory Stephens and other RIP co-founder James Leslie, entered the building. The house was dark, and the rooms were silent. The three were keeping their eyes wide open and their ears strained in the hope of making contact with the other side. They slowly crept up the creaky staircase, all the while keeping a constant watch of their surroundings. They reached the top of the stairs and stood motionless on the landing.

Silence once again engulfed them as they watched and waited with only the streetlights from outside the front windows offering any illumination. Suddenly, they heard it. From the other room, while everyone else in the group was outside, leaving the three ghost hunters alone in the house, came the unmistakable sound of innocent giggling that can only come from a young girl. Audrey was ready to play.

Audrey loves attention, and even after death, she has an incredible memory and attention to detail. For the second investigation of the Langdon Center, I arrived late after having attended my brother-in-law's graduation ceremony. I reached the house eager to jump right in to the investigation and see what I could find. It had been well over a year since our last ghost hunt at the Langdon Center, and until then my only real interaction with the

building had occurred on the front porch as I guided the weekly Ghosts and Legends Tour. I was excited to see if Audrey was still as active as ever. I was not disappointed.

Upon arrival, I was quickly ushered into the house to begin my own sweep. "Audrey has been really active tonight!" they told me. "See if you can get her to talk to you!"

During this investigation, they had been utilizing the popular flashlight trick. They added a slight twist to this one, however. This time, the flashlight was placed on the lap of an antique porcelain doll, another trigger object they hoped would entice Audrey into feeling comfortable enough to communicate with us. I was rushed into the house and sat down on the floor of the main room, facing the iron bench that held the doll and flashlight. To begin my sweep, I asked, "Hi, Audrey, it's me, Brandy! Do you remember me?"

I could barely get the last word out of my mouth before the flashlight clicked on, emitting a beam so bright it nearly blinded me. Upon later review of the evidence, it was made clear that of all the times the flashlight was turned on in response to questions throughout the night, this singular occasion was by far the brightest. Audrey was really using all her energy to make sure I knew she cared.

In addition, on the recording at the same time the flashlight let off its brilliant flare, the camera managed to pick up a little girl's voice saying, "Yeah!" Though it had been several months at least since I had set foot into that house, Audrey not only remembered me but was happy to see me again.

Along with the flashlight, an audio recorder was placed on the wrought-iron bench next to the porcelain doll. We were hoping to catch any electronic voice phenomena that may have occurred in conjunction with Audrey's use of the flashlight. At one point, in full view of the video camera and the ghost hunters themselves, Audrey suddenly decided she had either had enough of having to answer questions or else she wanted to make a grander gesture to provide us with evidence of her existence.

While the investigators were seated motionless in front of the bench, the audio recorder itself fell through the decorative holes in the seat and landed on the floor below. The stunned investigators paused for a moment to take in what they had just witnessed. They then came back to themselves and began the process of debunking what had just happened as something scientifically explained rather than supernatural.

Research and Investigation of the Paranormal is an excellent group in that it does not simply consider every unusual occurrence to be that of a ghostly visitation. Group members do all they can to re-create the alleged

supernatural encounter to make sure that all naturally occurring phenomena is accounted for before considering the supernatural.

Tyler Solomon placed the recorder back on the seat in the exact location where it had previously rested. He then proceeded to stomp as hard as he could all around the bench. Not even the doll moved. Solomon then began gently bumping the bench itself. This time the flashlight did roll off the doll's lap, but the recorder remained firmly in place. Nothing tangible was able to cause this recorder to move. No person was anywhere near the recorder when it fell, as was evidenced by the video camera that was trained on the bench at the time, and no one could have moved the recorder unless he had physically picked it up and moved it himself.

Though some may find her scary, at the heart of it all, Audrey is really just a little girl. She has the same emotions and desires that any other little girl may have. Throughout the ages, all little girls really want is the chance to play and be loved. They want attention and the acknowledgement that their presence matters. However, their desire for attention has a limit. There is one thing that Audrey, as is common with so many other girls her age, definitely does not like.

During the first ghost investigation of the Langdon Center, we brought with us a boy named Zachary. Being that he was only ten years old at the time, he was lovingly referred to as a "junior investigator." He attended the investigation under the watchful eyes of his mother, also a Research and Investigation of the Paranormal team member. All precautions were made to ensure this boy's safety. Zachary was not concerned, though. He was simply there to have fun and was so excited about the possibility of finding a ghost. The team thought that bringing a child with us would help trigger Audrey's emotions. We wanted to excite her by giving her someone a little closer to her age with whom she could relate. Based on what we knew of her experiences with the children taking music lessons, we made the educated guess that bringing Zachary along would incite some paranormal activity.

Zachary's presence did, in fact, instigate a piece of compelling evidence, but not exactly in the way we had imagined. While inside the house, Gregory Stephens was coaching Zachary: "Okay, now, make sure to keep quiet and really listen hard. See if Audrey might say something to you. Maybe she wants to come play."

It was later revealed on the recording that Audrey did respond but not with excitement. What was caught on the recording instead was a petulant, "I don't like boys!"

You could almost see her stamping her foot. How silly of us not to realize that a young boy was the last person Audrey would want to see. We failed to remember that boys are commonly infested with cooties and that the all-important "cootie shot" had probably not yet been invented in the early 1900s.

Although she may not like boys, at least Audrey still displays good sportsmanlike conduct. Later that same evening, Zachary sat down at the piano located in the front room and began to teach himself how to play "Mary Had a Little Lamb." He was having a rather rough time of it, finding it difficult to hit the right keys. Becoming frustrated with himself, he kept plugging along, determined to learn the song before the end of the night.

Finally, his goal was realized when he managed to plunk out the correct tune without any mistakes. He stood up from the piano, triumphant in his victory. Audrey could barely contain herself and shared in his delight. On the recording, as soon as the last note sounded, a very excited cry of joy was revealed. "Yay!" Audrey shouted in pride. She may not like boys, and they may, after all, have cooties, but even Audrey cannot deny when a great achievement has been reached.

Along with Audrey, there may possibly be a slightly more mischievous presence inside the Langdon Center. Whereas Audrey enjoyed the company of the ghost hunters coming to spend time with her, another spirit appeared to not want us there.

Perhaps it may be Alonzo Peyton Gordon simply acting as the protective grandfather to his sweet grandchild. He may have been suspicious as to why this group of strangers was invading his home in the middle of the night and was so eager to connect with his granddaughter. Because of this paternal instinct, the second investigation started becoming a little more difficult as the night continued, and it even bordered on dangerous.

The trouble began when one of the female ghost hunters suddenly had to make a quick exit from the building to avoid being sick. While standing upstairs in the office, she was suddenly knocked to the ground, as if her legs were taken right out from underneath her. She became light-headed and dizzy and was immediately brought back downstairs and out the door in the hope that some fresh air would rejuvenate her.

Though this lady may have had a rough evening, it was Gregory Stephens who seemed to be the spirit's primary target. Drawing from his military background, Stephens maintains a more provocative attitude in relation to his ghost hunting investigations. He retains the "tough guy" persona, refusing to be intimidated by any spirit, and thus he becomes susceptible to spirits who try their best to threaten him.

It should be said right here that provoking spirits is extremely dangerous and should only be done by those who have had extensive training in this field. Ghosts, when angered, can be harmful entities. I have been on several ghost hunts myself, and even I am not yet ready for the level of ghost hunting that would allow for actual provoking in a safe manner. I tend to call myself "the flatterer" in that I do not wish to anger the spirits into showing themselves. I take the stance of, "Nice ghost, pretty ghost!"

This technique tends to work for me, as people love to have their egos stroked—even people who are no longer living. This allows me to get evidence while not feeling fear that harm may come to me. As they say, you catch more flies with honey than vinegar.

Gregory Stephens, however, is most certainly not the flatterer. He is not insulting to the spirits; he does allow them to retain their dignity. All the same, sometimes the spirits do not appreciate his "take no prisoners" attitude. As Stephens stands in the middle of the room, legs spread in a defiant stance, he openly challenges the spirits to show themselves. And show themselves they do.

Stephens was spending a great deal of time in the upstairs offices at the Langdon Center. This upstairs area, which consists of one room on each side of the house with a small landing in between, was rife with at least one spirit who did not want us to be there. Audrey tended to stay on the downstairs floor to play, but the second floor was for the adults, and they meant business.

As Stephens stood in the room, calling for the spirits to communicate with him, he caught movement out of the corner of his eye. A shadow raced toward him, and he barely had time to register what he was seeing before the massive blow struck his head, bringing him to his knees. The rest of the group members rushed toward him, concerned that he was having a heart attack or other type of medical emergency. Stephens slowly returned to an upright position, brushing his knees and straightening his shirt. A ghost had literally just attacked him. This time, it was personal.

As if the physical attack was not bad enough, the ghosts then saw fit to begin taunting Gregory Stephens. The recording later revealed that at the same moment Stephens was hit in the head, an unknown woman began to laugh.

"Do it again!" she cried, enjoying the bit of slapstick comedy at the ghost hunter's expense. They literally were adding insult to injury. After this experience, Stephens decided he needed a better way to communicate more directly with the ghosts, so he brought out the heavy artillery.

The spirit box has been gaining ground in popularity among ghost hunters. It is an electronic voice phenomena recorder that allows you to hear a ghost's response in real time, rather than having to review the tapes later to see if anyone answered your questions. Because the basis for its operation lies in cycling through numerous FM radio frequencies, its usage is still debated among ghost hunting groups. How much of what is heard through the spirit box comes from the ghosts themselves, and how much is simply bled through from one of the radio stations?

However, there are a few indicators that what you are hearing could be real. For instance, sometimes you can be lucky enough to get an entire cohesive phrase or even a whole sentence in response to your answers. Because the box is constantly cycling through the frequencies, it does not rest on any station long enough to pick up more than one word at a time at most.

In addition, sometimes you can clearly hear a word or phrase that might be of a more, shall we say, adult nature. It is easy to assume that that response is probably from a ghost, because if any FM radio station were to utter such an expletive, that station would quickly come under heavy fire! During the Langdon Center investigation, we were fortunate enough to receive both types of evidence from the spirit box.

While standing in the same upstairs room where he received the blow to the head, Gregory Stephens switched on the spirit box. The squawk and beeps of the cycling frequencies filled the previously silent room. Stephens began his questioning, and it was not long before he found a spirit willing to provide a ready response to his interrogations. "Did A.P. [Gordon] hit me?" Stephens barked into the room.

"Did it!" The immediate answer was accompanied by a mocking tone.

"Why did A.P. hit me?" Stephens demanded angrily.

The ghost became quite blunt at this point. "I did it for fun," was his reply.

Toward the end of the investigation, the spirits seemed to become a bit more agitated. Gregory Stephens asked into the room, "Are there any negative spirits in here?"

"Yes," was the answer that came from the box.

Perhaps it was simply just A.P. Gordon getting tired of the interrogation, or it may have been someone else altogether. It was at this point, however, that the conversation quickly deteriorated, and we knew our remaining time at the investigation was limited. Never one to allow a negative entity to maintain the advantage, Stephens quickly jumped to the offense with a few choice words: "Well, negative spirit, you can just kiss my —."

Not to be outdone, the spirit box immediately shouted out one particular word that everyone standing in the room, including myself, easily understood. That word can best be described by the holiday classic film *A Christmas Story* as the "F, dash, dash, dash word." The spirit was definitely ready for us to leave.

The questioning continued on for a few more minutes, but we were getting little in the way of response. It was rather late, as ghost hunts tend to go well past midnight, especially if the investigations are lucky enough to yield plenty of compelling evidence. We were all tired, it was way past Audrey's bedtime and it was becoming obvious that the other ghosts had used up their remaining energy as well. We decided to turn in. Gregory Stephens wrapped it up by calling out his goodbyes to all the spirits he believed were there. "Goodbye, Audrey! Goodbye, A.P.! And to you, negative energy, kiss my —, and I am going to take you back to where you belong!"

The spirit box immediately chirped with the phrase, "Same here!" One last parting shot from the ghosts at the Langdon Center.

While Alonzo Peyton Gordon and any number of other ghosts may reside at the Langdon Center, Audrey is most certainly the star. She is one of our most popular attractions on the Granbury Ghosts and Legends Tour. Guests from week to week try their best at talking to Audrey in the hope that she may respond in kind. She loves every minute of the attention. During our second investigation, my mother asked, "Audrey, do you like it when the ghost tours come by here?"

This question received another very clear response from an excited little girl. The audio recorder picked up a distinct, "Yeah!"

It remains heartwarming, albeit in a slightly creepy way, to know that even one of the ghosts featured on the tour is one of our fans.

Though many people have had odd experiences while standing on that front porch, taking various orb pictures that could either be ghostly manifestations or simply dust floating in front of the lens, one of our visitors was lucky enough to receive a personal visit from Audrey herself.

The day after I conducted one of the Ghosts and Legends Tours, I received a phone call. On the other end was the excited voice of Miranda Scott, who had joined us for the tour the night before. "I got something! I got something!" she cried.

She went on to explain that as I finished the story at the Langdon Center and continued back down Pearl Street to the square, she decided to hang back with her daughter to snap some random pictures for a school project. It is important to note that these pictures were taken with nothing more

Inside Langdon Center looking at the window in which Audrey appeared in Miranda Scott's cellphone picture. Audrey appeared in the center window. *Author's collection.*

than a simple cellphone camera; no expensive ghost hunting equipment was used. This was merely a mother taking pictures of her daughter while on a fun outing. Scott and her daughter wanted to hurry and rejoin the group to avoid missing the next story, so she called out, "Bye, Audrey!"

She then snapped one more photo, this time of the front window to the left of the door, and quickly caught up to the group.

Later that night, as the family returned home, Miranda Scott began reviewing the pictures she took. When she reached that last picture of the Langdon Center, the picture she took immediately after calling out to Audrey, her heart skipped a beat. She could not quite believe what she was seeing. She had to get clarification from her other family members to make sure she was not merely seeing things. Even her husband, who leans more toward the skeptical side of the spectrum, upon seeing the picture admitted grudgingly, "Okay, yeah, I can see her."

After this explanation, I of course was immediately intrigued. I requested that she text the photograph to me, though it was difficult to see on my phone screen, so I sent it to my e-mail to be viewed on the computer. What I found as I opened my inbox left me speechless.

In the center of the window, down near the bottom, reaching to the proper height of a child of five, stood a figure. This was not merely a shadow figure, not an amorphous blob that could possibly look human if you tilt your head and squint your eyes. No, this was the clear, unmistakable figure of a little girl. The little girl appeared to be looking slightly down as the bottom half of her face was a bit hidden in shadow. Below her face, one could make out the old-fashioned high collar that was the style in the early 1900s. Her hair was parted down the middle with a small pigtail or bun on either side of her head. "Bye, Audrey!" the woman had called out.

Audrey did not want to say goodbye.

CHAPTER 5

JOHN ST. HELEN...
OR JOHN WILKES BOOTH

THE GRANBURY OPERA HOUSE

The most popular ghost story in Granbury centers around one of our most iconic buildings: the Granbury Opera House. Ask anyone in town about ghosts in Granbury, and the first thing he or she will say is, "Have you heard about the opera house?"

The mystery behind the Granbury Opera House has been widely discussed in various books, newspaper and magazine articles and television shows. It is common for theaters to be haunted, and any theater worth its salt always comes with at least one good ghost story. From stagehands and actors to even audience members meeting their untimely deaths during productions, theaters across the world tend to be virtual havens for spirits. However, not many theaters are able to boast the possibility that their ghost is none other than notorious presidential assassin John Wilkes Booth.

The Granbury Opera House was built in 1886 at 133 East Pearl Street. This ornate building on the south side of the square is the jewel of downtown Granbury. The pressed tin detailing found along this massive two-story stone structure adds to the grandiose atmosphere of frivolity and decadence that grand theater itself is meant to represent. According to the book *Historic Hood County* by Mary Saltarelli, the building "presented traveling vaudeville acts, minstrel shows, acrobats, magicians, sword-swallowing feats, and even works of Shakespeare." The Granbury Opera House was a one-stop shop for entertainment needs and was the central attraction of Granbury's downtown square.

Ghosts and Legends Tour visitors enjoying the story of John Wilkes Booth at the Granbury Opera House. *Author's collection.*

Any number of ghosts can be experienced at the Granbury Opera House. Phantom footsteps are commonly heard in the balcony, and doors tend to open and close on their own. One evening, a man alone inside the theater heard a strange noise. He knew he had heard it somewhere before but could

not quite seem to place it. It finally occurred to him: the sound he was hearing was that of a sewing machine running. However, no one else was in the building that night, certainly not any costume designers, and strangest of all, the machine sounded as if it was being operated by a foot pedal, the kind primarily seen in past centuries, and not the more modern machine one would use in the present day to add last-minute stitching to a costume. It appeared that someone was working overtime to finish before the curtain call, but who?

Carol Cooper was the assistant house manager at the Granbury Opera House for seven years. Through her tenure, she was no stranger to the unexplained phenomena that surrounded the building. As they were setting up a new show, Cooper and a few colleagues sat down to try out the Ouija board that was used as a stage prop.

Let me interject here with a word of caution. It is suggested by many members of the ghost hunting community that you should never play with a Ouija board. It may appear to be a simple board game available at any toy store. What could possibly be the harm in that? It could, in fact, be very harmful. Use of a Ouija board, especially by those who are not properly trained in dealing with the supernatural, can be extremely dangerous. As Selena Roane, a prominent ghost hunter with FEAR (For Everything a Reason) Paranormal, put it, "I feel they invite spirits we may not want to be in contact with. My own personal opinion is I just won't use them ever. I will stick to my audio recorder and cameras." If you still insist on playing with a Ouija board, do so at your own risk, because you never know just what you may be inviting in.

Carol Cooper and her friends learned this hard lesson themselves. They playfully asked, "Oh Ouija, is there anyone here with us?"

The sudden chill they all received was enough answer for them. In Texas, during any other season besides winter, and sometimes even in winter itself, when you feel an immediate cold sensation, you are probably either becoming ill or something otherworldly is near you. Realizing the unlikeliness of every member of their group becoming struck by a sudden bout of the flu at the same time, they reasoned that perhaps provoking the spirits in such a haunted location may not be the best idea. So they decided to remove the board and begin their questions again in the prop and costume shop, where they felt they may be safer than in the theater itself.

The spirits would not be deterred, however, and were all too eager to answer. From the group's questions, they learned the names and back stories of three possible spirits residing in the opera house: Krewa, PB and Zeb. PB was an actress who was married to the love of her life. However, she found

herself the object of Krewa's unrequited love. Krewa was a Russian actor who felt that if he could not have PB for himself, no one could. His jealous longing for the actress ate at him until he became filled with resentful hatred. Zeb was there as protection for PB, to keep her safe from the covetous hands of Krewa and to look after the Granbury Opera House.

The bevy of information supplied by the Ouija board threw the friends for a loop. But nothing could quite prepare Carol Cooper for what she was about to learn next. The Ouija board then revealed that Cooper looked just like PB. The board went on to warn that the resemblance had triggered a spark inside Krewa, igniting his jealous rage, and he intended to make Cooper his next target. Cooper was shaken, in fear for her life, hoping she would not become the victim at the hands of an envious ghost.

Luckily, Krewa lowered his murderous intentions to those of simple annoyance. A few months later, Carol Cooper found herself painting the box office with an actress from the theater company, enjoying the work while dancing to the music playing on the radio. The owner of the shop next door came by, looking for help in moving a display, hoping to find some strong men who are used to moving heavy set pieces on and off the stage. Because Cooper and the actress were the only ones in the building, they left instead to help the shop owner, leaving the radio playing as they only intended to be gone for a few minutes.

When they returned no more than ten minutes later, the radio had changed to a station that is nowhere near the station Cooper prefers. Had it been slightly tuned to the side, it could be explained away by saying perhaps someone had simply bumped it. However, in considering the fact that no one else was in the building to have bumped it, as well as the fact that the radio dial was tuned clear to the other end of the frequency, Cooper realized it had to be one of their unseen residents having a little fun. Cooper called out in exasperation, "Krewa, cut it out! Put it back on my station!"

The radio immediately changed back to her regular station, dialed by invisible hands. Perhaps Krewa was simply trying to motivate them to work faster. Carol Cooper and the actress decided then and there to finish the painting very quickly and hightail it out of there, leaving only a trail of dust in their wake.

If, as the Ouija board had revealed, Krewa had intended to hurt or annoy Carol Cooper, at least it seems Zeb was there to help her. One day, Cooper was walking with a friend up the steps from the lobby to the seating area. Not properly calculating the height of the step (I, myself, am cursed with this same affliction), she stubbed her toe on the next step up, causing her to fall

forward. There was little time for repositioning. Cooper knew she was going to fall, and she was going to land hard on the unforgiving ground.

As she prepared herself for the nasty impact, Cooper suddenly found herself braced by phantom arms in front of her shoulders. Someone or something held her upper torso upright, allowing her to simply land on her knee, rather than her face, as her previous trajectory would have caused. Zeb, PB or perhaps even Krewa himself in a sudden change of heart rescued Carol Cooper from a painful fall and possibly even a trip to the hospital.

The ghosts of the Granbury Opera House have perplexed local law enforcement as well. In 1976, having newly reopened after an extensive renovation project, the theater company was winding up a dress rehearsal when a Granbury police officer walked through the back door. The officer wanted to know the identity of the man whom he had just witnessed walk through the front door. The company assured the officer that the front door was locked and that no one could have come in.

At the same time, a seat in the balcony popped up into its normal upright resting position, as if someone had just been sitting there and suddenly stood up. The officer and his partner confirmed that the front door was indeed locked and that there was no one in the balcony. Perhaps the man was simply wanting to take a sneak peek before opening night. Or perhaps the recent renovations themselves had triggered his appearance.

Construction and remodeling are common catalysts for spirits. If ghosts are tied to a building, they are probably there for good reason, and they are not usually too keen on other people making changes to what they still consider to be their property.

The man the police officers saw could have been anyone. He could have been Zeb or Krewa or maybe even a

Portrait of John Wilkes Booth. *Public domain.*

different patron of the arts that was too shy to speak over the Ouija board. It could also be very possible that the man they saw was, in fact, the most famous ghost in Granbury.

The legend of John Wilkes Booth in Granbury has been a popular one for decades. Legend has it that the man in the barn who was killed in Virginia was not John Wilkes Booth but was, in actuality, a man with red hair and freckles. The real assassin made his escape, finally settling in this area of Texas under the name John St. Helen, reportedly because Booth had a family member living in the nearby town of Glen Rose.

Here in Granbury, St. Helen would act in the theater while tending bar at the saloon next door. St. Helen was known for walking with a limp, as though his leg had been broken in the past. Booth, of course, had indeed broken his leg after assassinating the president as he leapt from the balcony above to the stage below, calling out, "Sic semper tyrannis!"

It was also said that St. Helen rarely ever drank, and when he did, he always managed to hold his liquor quite well, maintaining the appearance of sobriety. However, on the evening of April 14, the anniversary of Lincoln's assassination, St. Helen was reported to have been found completely three sheets to the wind. Perhaps John St. Helen was trying to quell a guilty conscience?

The legend of St. Helen's connection to Booth, however, really took off when St. Helen found himself on what he believed to be his deathbed. He decided to confess to A.P. Gordon's brother, F.J. Gordon, along with a lawyer from Memphis named Finis Langdon Bates that he was, in fact, John Wilkes Booth and had assassinated President Abraham Lincoln. According to Bates's book, *The Escape and Suicide of John Wilkes Booth*, Booth told them, "I am dying. My name is John Wilkes Booth, and I am the assassin of President Lincoln. Get the picture of myself from under the pillow. I leave it with you for my future identification. Notify my brother Edwin Booth, of New York City."

St. Helen also reportedly gave detailed directions to where he had hidden the murder weapon, directions F.J. Gordon followed, allowing him to easily recover the weapon in a house near Granbury's downtown square. The gun was wrapped in newspaper articles about Lincoln's assassination.

John St. Helen recovered from his illness and quickly left town in order to avoid apprehension for assassinating the president. Years later, a man named David E. George committed suicide in Enid, Oklahoma. George had previously confessed to others as being John Wilkes Booth as well. The body of David George was later mummified and entered into the carnival

sideshow circuit. The mummy changed hands throughout the years and was last seen in the 1970s. To this day, the exact whereabouts of the mummy remain a mystery, though many attempts to locate it have taken place throughout the years.

John St. Helen's escape from his would-be deathbed should have ended his chapter in Granbury. However, many people believe that he still resides here, especially in the Granbury Opera House, where he loved to perform. The most compelling evidence for St. Helen's presence in Granbury came from the Klinge brothers, ghost hunters and stars of *Ghost Lab* on the Discovery Channel. Brad Klinge had always been interested in Civil War history, and when he heard the stories of John Wilkes Booth at the Granbury Opera House, he knew he had to jump at the chance to investigate. What the brothers found was astounding.

"It was one of the greatest moments we have had in ghost hunting," Klinge told me. "We hit the lottery!"

Most of the investigation took place similar to any other investigation with the glimpsing of ephemeral figures and other standard evidence of a haunting. The crew members were on stage looking into the audience and witnessed someone walking through the seats. They later saw a man with a wide-brimmed hat walking across the back of the theater as they stood on the stage looking toward the back of the house.

They caught a blob by the stage on one of the motion-activated cameras that they had set up overnight. This was a game camera more commonly used to catch wildlife. It will not snap a photo unless there is a physical being in front of the lens. Since they left the camera running throughout the night even after they left the investigation, there was no one else in the building when that photo was snapped. Yet somehow, something registered as being physical enough to trigger the camera's mechanism and to show up on screen.

One film crew assistant even refused to go back inside the building when his backpack was ripped right off his body. However, it was one single piece of audio that made this investigation truly extraordinary.

Brad Klinge had obtained a replica of the gun used by John Wilkes Booth to assassinate President Lincoln. He used this replica as a trigger object, hoping to excite the spirit enough into creating evidence. Brad brandished the gun, calling out to Booth, doing his best to provoke him. And provoke him he did. On the EVP recorder, the crew all clearly heard a man saying, "Yes, I'm John Wilkes Booth!"

That was the actual piece of audio presented on the Granbury Opera House episode of *Ghost Lab*, which aired on the Discovery Channel in 2009.

However, Klinge confessed to me that the sound bite had been slightly edited by the Discovery Channel authorities. Being a television network that features family programming, the editors at the Discovery Channel felt it might be in their best interest not to include the entire clip. The whole phrase heard by Brad Klinge and his crew was, in actuality, "Yes, I'm John Wilkes Booth, you b—d!"

Klinge and the others were taken aback. They could not believe they had just received clear audio evidence not only of a ghost but also of a ghost of one of the most infamous killers in history. Klinge told me he felt this audio statement was Booth's confessional. They sent the recording to the Federal Bureau of Investigation for voice analysis, giving them no prior information on the background of the clip. The FBI returned with the results that the voice definitely has human qualities, but it does not register on the human scale. This means that while a human did say the words, it could not have been a living human.

Close-up of the Granbury Opera House sign. *Author's collection.*

Prior to commencing the investigation, Brad Klinge conducted extensive research for background information. He spoke with family members of John Wilkes Booth, historians and conspiracy theorists. He told me that simply from his research alone, he would truly believe the story that John St. Helen was indeed John Wilkes Booth even if he had not managed to get the audio recording. "It's amazing how possible it is to be true!" he said.

Several years ago, John Wilkes Booth was spotted once more, but this time he was in the mood to travel. A man was spotted inside the Granbury Opera House by members of the opera house company themselves. He was later described as someone who looked exactly like a picture they had previously seen of John Wilkes Booth. They were startled to find an unknown man inside the building, so they cried out, "Hey! What are you doing here?"

The man was frightened to have been discovered and quickly took flight out the door and down the street. They managed to chase him down the sidewalk and witnessed as he ran into a nearby building. They knew they had him then. This empty building had been boarded up, and the only way in or out was through the same front door that the mysterious stranger had just entered. They followed him through the front door only to discover that they were alone inside the building. They had obviously witnessed him run inside, and no one had seen him run back out, but somehow within the few seconds before they reached the door, the man had vanished.

Is John St. Helen really John Wilkes Booth? We will probably never know beyond a shadow of a doubt. His presence—or the possibility of his presence—helps add to the legacy of the Granbury Opera House and Granbury in general. After all, what better person to wind up in a town where outlaws are welcome than one of the most well-known outlaws of all time? The story of John Wilkes Booth/John St. Helen has haunted this town for years and will continue to do so for many years to come. The show must go on.

CHAPTER 6

THE LADY IN RED

THE NUTSHELL EATERY & BAKERY

If John Wilkes Booth enjoys spending time where he used to perform, he also must have had some lovely experiences at his old job. While working as an actor, John St. Helen made ends meet by bartending at the saloon and mercantile store owned by A.P. Gordon next door to the Granbury Opera House.

Constructed in 1885, the building that once housed Gordon's store at 137 East Pearl Street, still in the original limestone building, remains true to its original 1800s look to this day. From the decorative arches above the front door and the large, inviting windows flanking the door's sides to its rustic metal staircase traveling up the side of the building and leading to the living quarters above, the building is swathed in old-fashioned charm. Employees at the Nutshell Eatery & Bakery, located where Gordon's business once stood, believe that St. Helen likes to visit his old place of employment from time to time.

Kay Collerain, owner of the Nutshell Eatery & Bakery, has had plenty of run-ins with a man she believes to be John St. Helen. She would often hear footsteps and voices, as if several people were having a conversation, but could never quite make out what they were saying. At one point, she was living in the apartment upstairs above the restaurant. It would be a common occurrence for her to hear the door of the restaurant open and close as if visitors were entering the establishment while she was upstairs after the restaurant had closed.

As much as Collerain has experienced in her many years of running the Nutshell, she has been truly frightened only once. She was lying in bed at

Upstairs eating area at Nutshell Eatery & Bakery. Note the newspaper article about John Wilkes Booth on the far wall. *Author's collection.*

night in her apartment above the restaurant with her Doberman resting comfortably beside her. It was late at night, and she was completely alone in the building. All at once, the dog jumped up and ran from the room, his fur raised in a sign of aggression, growling and barking at the intruder. Collerain herself could feel a presence in the apartment as well and tried to settle her nerves while at the same time getting her dog under control. The Doberman sniffed everywhere, thoroughly investigating every inch of the apartment, but neither the dog nor Collerain could find any trace of a person.

Cheyenne Collins, an employee of the Nutshell Eatery & Bakery, has had her share of ghostly experiences as well. She will sometimes hear her name called early in the morning when no one else is around. Sometimes she will see the lights flicker up and down the staircase and even see people walk by the pick-up window but never reach the front counter.

Perhaps the most startling occurrence is when the ghost decides he or she wants a little extra attention. At the pick-up window, employees utilize a microphone to announce when an order is ready. This microphone requires

John Wilkes Booth is included in the mural on the Nutshell Eatery & Bakery wall. *Author's collection.*

a button to be pushed in order to turn it on. There are times when no one is around the microphone that it will nevertheless somehow turn itself on. Unintelligible screaming will suddenly be heard over the loudspeakers, thoroughly startling anyone inside the building.

Another enduring ghostly legend of the Nutshell Eatery & Bakery is that of the Lady in Red. Longtime Nutshell Eatery & Bakery employee Linda Wark has encountered this woman on a regular basis. It is believed that while the bottom portion of the building was once a saloon, the upstairs level of the building served as, to put it gently, an area where men could find company for the evening. This ghostly apparition could possibly be the owner of that establishment.

She is often seen, most commonly by children, standing on the staircase. She is described as wearing a long red dress, her blond hair flowing under an ornate and voluminous black hat. It is her iconic red dress that has allowed us to bestow upon her the nickname of the Lady in Red.

The Lady in Red is a playful spirit; she loves to annoy the workers and visitors, and she seems to have had a special affinity for Linda Wark ever since

Wark began her employment with the Nutshell in 1990. She will often come up behind people and call their name in Wark's voice when Wark herself is nowhere near. The Lady in Red especially prides herself on messing with those who either do not believe in spirits or who are already scared of them.

A customer came in one day and ordered his food. It was a slow moment in the day, and he was the only customer in the building at the time. When he placed the food on the table, he went to the drink station to retrieve some coffee. Upon returning to the table, he made a remarkable discovery. His food—all of his food, including the plate itself—was missing. Wark assisted him in his search for the missing food but came up empty-handed. It was only after they moved the booth out from the wall that they discovered the food underneath the booth in the corner on the floor.

The Lady in Red is not immune to the occasional hissy fit. If something does not go her way, she will do all she can to make sure everyone around her knows how she feels. Years ago, workers performed quite a bit of remodeling of the outside area of the building, namely taking up the wooden floorboards outside the side door and installing a proper concrete sidewalk. The Lady was not happy about this new development and demonstrated her emotions by throwing pots and pans across the room. It was almost as if a war zone had erupted, with kitchen utensils flying through the air. As Wark put it, "You would either duck or get hit!"

The wall of the Nutshell Eatery & Bakery boasts beautiful murals portraying the feel of the Old West saloon days. Even John Wilkes Booth is pictured on the wall, standing ironically next to his own "Wanted" poster. Also depicted on the wall is a woman in a long red dress sitting next to the bar, the muralist's homage to the ghostly spirit that lives there. The muralist experienced her own encounter with the Lady in Red while completing these paintings. Whether the Lady appreciated the muralist's recognition or she disliked how she looked, she was quite active during the painting process.

While standing high on a ladder working alone one evening, the muralist noticed that the volume on her radio was suddenly turned down. She puzzled for a moment, then climbed down, readjusted the radio and then climbed back up to resume her work. Upon reaching the top of the ladder, her radio was immediately turned back down to the lower volume. Unsure if this was the result of an electronic glitch or something otherworldly, the muralist gave a sigh and began her trek back down the ladder. After making this same journey several times in one evening, with the radio always turning back down once she resumed her work, the muralist began to get frustrated.

Depiction of the Lady in Red in the mural on the Nutshell Eatery & Bakery wall. *Author's collection.*

When Wark arrived and saw what was going on, she took matters into her own hands. Wark has never been one to put up with ghostly shenanigans, which is probably why she finds herself targeted by the Lady. Wark called out sternly, "Stop messing with the radio!"

This was enough to put the Lady in a true frenzy. No one could tell her what to do! The Lady in Red immediately began banging the salt and pepper

shakers down on the table near the front. When that racket wasn't enough, she then threw the shakers at the front window, thankfully not breaking the glass.

Wark and the muralist watched in awe, but they would not budge. Defeated, the Lady set the shakers back on the table. The two women heard a flurry of movement as the Lady in Red then ran past them and fled up the stairs, knowing this was a fight she could not win.

The Lady in Red was not finished with the muralist just yet. One evening, upon finishing her work, the muralist went to put her brushes away. However, her efforts were thwarted when she discovered that her brushes were missing. Why would someone steal over twenty paintbrushes? They were just there! Wark assisted the muralist in searching for the purloined paintbrushes, but once again, they could not find the missing items.

The next morning, Wark arrived for work at the Nutshell and noticed something odd near the front of the building. The brushes, all twenty-five of them, were discovered. They were all buried, bristles down, in the ficus tree outside on the sidewalk. They were buried so deeply, in fact, that only about one-quarter of each handle was visible sticking out of the dirt.

The Lady in Red has actually been seen on the Granbury Ghosts and Legends Tour as well. After I concluded the tour one evening, a mother and her daughter walked up to me. The girl, about twelve years old if not slightly older, seemed a bit shy to be approaching me, but her mother encouraged her to speak. The girl confessed to me that she had seen one of the ghosts on the tour! While we were standing at the Nutshell Eatery & Bakery, before I began telling my story, the girl saw an image.

The young lady assured me that this was before I mentioned anything about who may be haunting the location, so it was not merely her imagination being led by suggestion. That can sometimes be a problem when people are searching for the supernatural; people see what they want to see and not what they actually see. The mind is highly susceptible to suggestion. This is why, even though I wholeheartedly believe in spirits and the supernatural, I sometimes maintain an air of skepticism when people tell me they have seen something on the tour. How much of that is real, and how much of it is the mind manifesting a suggested image to enhance their spooky good time?

However, I was reassured that this was not the case for the young girl as she had no prior knowledge when she saw the vision. What she saw, looking into the window of the Nutshell Eatery & Bakery, was a glimpse of a woman standing on the staircase. The girl could clearly see a lady's hand gripping the railing, and a woman's hip clad in red jutted out to the side in a saucy manner. The Lady in Red was posing for her audience.

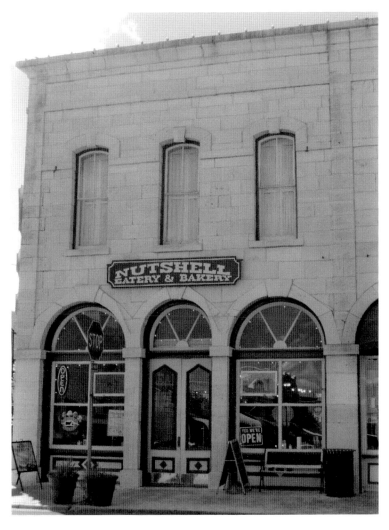

Present-day exterior of the Nutshell Eatery & Bakery. *Author's collection.*

At the Nutshell Eatery & Bakery, fans of the supernatural can enjoy more than delicious chocolate chip cookies and homemade sandwiches. From John Wilkes Booth to the Lady in Red, paranormal activity runs rampant in the building that dates back to 1885. According to Kay Collerain, when A.P. Gordon sold dry goods and groceries in his store, a popular saying stated, "If you can't find anything at Old A.P.'s, it's not to be found!" That saying is particularly true if what you are looking for is thrills and chills.

THE LITTLE FACELESS GIRL

THE WEST SIDE OF THE SQUARE

A man and his wife walked through the front door of Market on the Square one day, said owner Melba White. The man immediately made a beeline for the staircase leading to the loft above. As he reached the top, he turned and called back, "If you hear me talking, I'm just talking to the little girl!"

This little girl has been a popular source of mystery and wonder for patrons and employees of Market on the Square for many years. Who is she? Where did she come from? An article in the *Hood County News* reports that one popular story declares a little girl had been left behind in Granbury by a circus many years ago. She wandered the streets of the square, alone and afraid, before eventually passing away somewhere downtown, presumably on Houston Street, where this spirit tends to reside.

Another belief is that the little girl was actually watching the circus parade pass by when she fell from an upstairs window. Indeed, the psychic impressions from spiritual medium Deborah Carr Senger as she joined the Ghosts and Legends Tour support the theory that a circus played a pivotal role in this little girl's death. Senger received the distinct impression of "a circus coming into town, an unfortunate event and then it [the circus] never returned." The death of an innocent little girl is at all times "an unfortunate event." Either way, whether she was the circus spectator or the circus act, the mystery of her appearance proves to be one that will not be solved anytime soon.

The building itself is certainly full of vibrant history. The property at 112 North Houston Street began its life as the Palace Saloon, a one-story

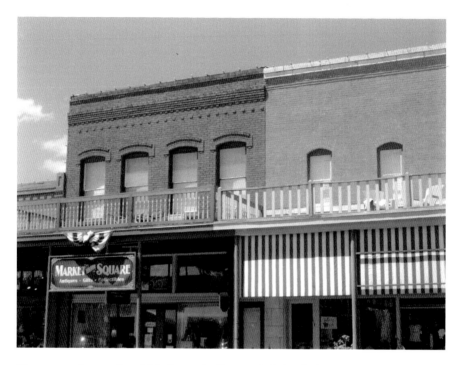

The present-day exterior of Market on the Square. *Author's collection.*

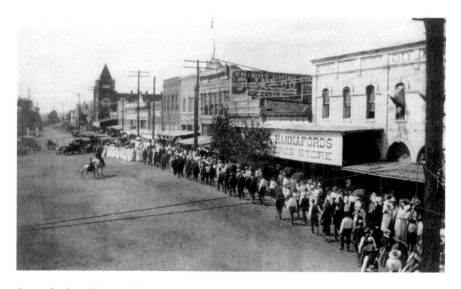

A parade along the west side of the square where Market on the Square currently stands. *Courtesy of Laurel Pirkle.*

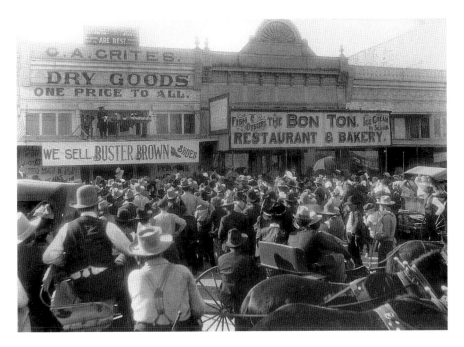

A crowd gathering to see Buster Brown, a popular shoe spokesman, on his visit to the west side of the square, circa 1917. *Courtesy of Laurel Pirkle.*

wooden structure operated by J.W. Anderson. Historian T.T. Ewell wrote in *Hood County History* that Anderson "had been, in Granbury's early history, a man of reckless associations, until his conversion and union with the church about 1883." The Palace Saloon, like much of Granbury's square at the time, was a raucous destination.

M.H. Shanley purchased the building in 1889 and converted it into a dry goods and clothing business. It was at this time that the current two-story building was constructed, with the second floor acting as the Granbury Telephone Exchange in the early 1900s. Since then, the upstairs floor has been converted into apartments, hosting tenants who almost all have had supernatural experiences during their stays.

The most well-known and chilling incident to happen in the apartment occurred in 1992. A man was visiting his son who lived there. Around 2:00 a.m., the man awoke with the feeling that something was not quite right. He looked up from the bed to find a young girl standing near his side. She wore a green skirt, her hands folded demurely over the fabric, and she did not speak or move. There was only one detail he could not seem to make out; she appeared to have a gauze-like material covering her face, rendering

him unable to see her clearly. He later told the *Hood County News*, "I wasn't frightened. She was a friendly ghost."

This man has been the only one to make visual contact with the Little Faceless Girl. Perhaps she misses her own father, and this man possessed some quality to invoke her memory of the paternal figure she lost so long ago when she was abandoned.

The next morning, the traveler described to his son the bizarre details of the night before. The son suddenly turned pale, as he had never discussed the possibility of a ghost with his father but had certainly experienced his fair share of odd happenings. He told his father that he had never seen her himself but had heard evidence of her, such as pans rattling in the kitchen.

This man and his father are not the only tenants who have experienced something otherworldly in this upstairs apartment. Other occupants have reported hearing the haunting giggles of a small child when no one is around. Items have a way of disappearing and then reappearing.

One renter in particular ended up breaking her lease early specifically because of the supernatural occurrences that happened frequently while she lived there. After closing the windows firmly, and distinctly remembering having done so, she would come back to find that someone or something had opened the windows again. She finally decided this was her last straw and wanted out of that apartment. Maybe the Little Faceless Girl simply wanted a better view of the street in case any circuses should come parading by.

The Little Faceless Girl may have even caused a casualty herself inside the building. One former occupant noted that their dog looked as if he was chasing something that no one else could see. Hot on the trail, frantically tracking the phantom scent, the dog suddenly plunged from the landing. Sadly, the beloved family pet perished from the ordeal, and the family never fully discovered the source of his torment. Could it be perhaps that the little girl was lonely and simply wanted a furry companion of her own?

A shocking discovery was made by yet another tenant. While moving an antique couch upstairs, he noticed a strange object stuck deep inside. He removed the cushions, pulled back the stapled gauze cover and discovered something white sandwiched between the springs. Upon removal of the object, he was astounded to realize that he was holding a pair of small white lace gloves—gloves that would fit perfectly on the hands of a little girl.

The Little Faceless Girl's antics have not been confined to Market on the Square, however. It seems she enjoys traveling up and down the west side of the square, also known as Houston Street. Melinda Ray, owner of a bookstore that used to be located on the west side at 124 North Houston

Street, gave me a chilling account of an incident that occurred as one of her employees was working alone at the store.

At the back of the store, there was a section for toys and other children's items. In this section, there was a display tree filled with hanging stuffed monkeys, the kind that let out an ear-splitting shriek when you press them in the middle. One evening, her employee was closing up at the front counter, reconciling the books and finishing paperwork, completely alone in the store, when he became startled by a strange sensation.

The lights were dimmed, the door was locked and the sun had set below the horizon. As he was finishing his work on the computer, he felt the sudden chill that can only be explained by the unexplained. The cold, however, was not nearly as disturbing as the unexpected sound that immediately rang in his ear. Or, to put it in a better way, the *many* unexpected sounds that rang in his ear: every single stuffed monkey on that monkey tree letting out their horrible shrieks all at once. This terrifying incident marked the end of that particular employee ever working alone past sunset.

The Little Faceless Girl seems to enjoy visiting another store on the square, known as Artefactz at 120 North Houston Street. When I accompanied my

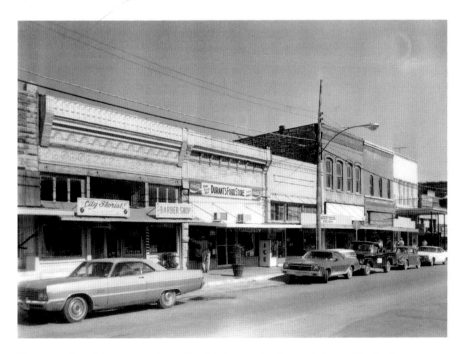

The west side of the square, circa 1964. Market on the Square is located in the first two-story building from the left. *Courtesy of Laurel Pirkle.*

ghost hunting group, Research and Investigation of the Paranormal, to a ghost investigation inside this store, I received a rare treat. For the first time ever, I actually was able to hear a ghost communicate with me through my naked ear rather than having to listen to EVPs. I was joined in the upstairs loft by my mother and another woman from the group. I had arrived to the investigation late, and apparently the ghost had previously indicated that she would like to speak with me.

Never wanting to disappoint, I immediately headed upstairs to see what she had to say. While up there, we would talk and ask questions, and the various pieces of equipment would light up as if in response to what we were saying. As it grew a little later, we decided to leave to give other group members a chance to investigate.

The other woman with us said out loud, "Okay, we are going to go back downstairs now if that's what you want us to do!"

The words had barely left her lips when all three of us simultaneously heard a very loud, "Uh!"

This was uttered in an unmistakably high-pitched voice that could only belong to a little girl. Just to be sure, we radioed down to the other

The present-day exterior of Artefactz. *Author's collection.*

investigators to make sure that none of them had for some reason voiced that syllable, and they all confirmed that they had been silent. Apparently, the little girl was enjoying the attention and did not want us to leave.

She was also quite curious about what we were doing. As the group was setting up its equipment, the recorder was already running to attempt to catch as many electronic voice phenomena recordings as possible. The little girl's voice came through clear as a bell, inquiring, "Who are these people?"

The Little Faceless Girl does not appear to be the only spirit residing at Artefactz. The recordings during the investigation frequently picked up a gruff man's voice, perhaps that of an old cowboy, someone used to hard work and the ways of the West. As the group's co-founder Gregory Stephens entered the building to begin one of the sweeps, the recording picked up the man asking, "What are they doing here?"

After a pause, the man continued, "He won't move!" He must be protective of the store and appeared frustrated that he cannot exert his will on others.

The cowboy later mentioned, "I'm looking for respect!" Oddly enough, this audio recording occurred just before Stephens's wife, Laura, started discussing how the youth of today do not seem to show proper respect to their elders anymore. Because voices coming over the audio recorders are not audible until later review of the tapes, there was no way she could have known that a spirit was talking about the same subject as she. Perhaps he somehow knew what she was going to say?

This mysterious man's protective spirit continued to shine through as the night wore on. Later, when Gregory Stephens was asking the spirits if they approve of how the store has been run in the past decades, the cowboy came through again, gruffly stating, "Not going to talk about the store!"

As store owner Cynthia James was climbing the stairs during a sweep, the recording picked up, "Please take care not to fall!" The old-fashioned phraseology of that sentence clearly points to a person from another century. A more modern person would certainly have worded that phrase in a much more casual manner.

This cowboy at Artefactz seems to be consistent with another possible haunting on that same street. Brazos Moon Antiques, located at 124 North Houston Street, the same location as the site of the terrifying stuffed monkey incident at the bookstore, has found itself home to a cowboy as well.

According to owner Cherry Hanneman, this cowboy has been spotted on at least two separate occasions inside the store. The first sighting was made by a young girl about the age of five. She accompanied her mother into the store. While her mother and Hanneman were holding a conversation at the

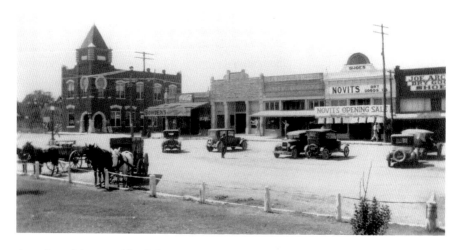

A portion of the west side of the square, circa 1922. *Courtesy of Laurel Pirkle.*

front counter, the little girl wandered off to explore. As she returned to the front, her mother looked down and asked her where she had been.

"Upstairs," the little girl replied, innocently, "talking to the man."

Hanneman and the girl's mother grew concerned, as they were sure no one else was inside the store besides the three of them. Hanneman asked the little girl where this mysterious man was. The girl indicated that he had been by the free-standing display rack of cowboy hats they had for sale upstairs. The young girl went on to explain that he had been dressed all in black but had some difficulty in describing exactly what his clothes looked like. Knowing about the odd ghostly occurrences in the building, Hanneman encouraged her to remember more details, all the while remaining careful not to ask any leading questions that could implant ideas into the girl's head and compromise her experience.

Hanneman asked, "Is he dressed like us?"

The girl replied with a definitive, "No."

Hanneman then asked the girl if he was dressed "old-timey," to which she replied, "Yes!" Hanneman then informed the girl and her mother about the otherworldly experiences inside the building, and she gave the girl the distinction of being the first person ever to actually spot him.

Another spine-tingling encounter with the cowboy inside **Brazos Moon Antiques** involved a young couple at the store. The couple walked through

the door near closing time one evening, after having been shopping there earlier in the afternoon. They were idling near the front counter, unsure of what to say or do. Finally, the husband sighed.

"Just ask her," he told his wife.

His wife timidly asked Cherry Hanneman if the store might have a ghost inside.

Hanneman, to the young woman's relief, answered, "Yes, as a matter of fact, we do!"

The woman then recounted her story. Earlier in the day, the couple had found themselves in the back of the store on the bottom floor. They were just near the entrance to the back workroom, which was partitioned off with a beaded curtain so customers would know it was off-limits to anyone other than employees. The young wife glanced into the workroom as she was shopping and received quite a shock. There, on the other side of the beads, sitting on a stool was a man wearing an old, long, black coat, dirty from years of wear, along with cowboy boots and a big black hat. He was chewing on a long straw and, much to the young lady's distress, was staring very intently at her.

"Why is that man staring at me?" the young woman asked her husband.

"What man?" he replied, looking up from his shopping.

"That man sitting in the back room!" she insisted.

However, when they both looked into the back room, mere seconds later, the man was nowhere to be found. He apparently had even taken the stool itself with him, because Cherry Hanneman maintains that they have never had a stool like that back there. After their story, Hanneman asked the lady if it looked like the coat the man was wearing was actually a duster, the popular outerwear for cowboys. The young wife affirmed that it was. Could this be the same cowboy that was discovered during the investigation at Artefactz? Because the stores are all closely situated along the same side of the street, it is easy to conclude that perhaps their ghost stories are all closely linked as well.

A perhaps more sinister plot may have been uncovered from the investigation of Artefactz as well. One recording revealed a young boy sounding very distressed.

"Grandma, this syrup tastes awful!" the boy exclaimed.

He might have simply been protesting over the less-than-palatable taste of his medicine. However, a later recording caught a young girl, perhaps the Little Faceless Girl herself, remarking, "It's not right. He was my friend!"

Did a young child meet a tragic end at the hands of his family, or was his untimely death simply caused by an illness that his female friend could not bring herself to understand, causing her to place the blame on others?

Through all her travels, however, Market on the Square appears to be where the Little Faceless Girl prefers to call home. Ginny-Rea Urban, a longtime vendor at Market on the Square, has felt her energy and witnessed evidence of her presence countless times. She was chatting with another woman in the back of the store one day. In an instant, they felt a child pass between them, causing the hair on their arms to stand on end.

"There were times I would walk in the door, and a burst of energy would hit me that was so powerful, it would cause me to immediately drop anything I was holding," she told me. "It felt as if the girl simply had been feeling alone and wanted attention."

The Little Faceless Girl is indeed a girl just like any other. Evidence of her playful nature has been spotted from time to time. Urban would find that the tea set that was normally enclosed in the wicker basket in the back of the store was mysteriously taken out of the basket and arranged as if someone had been having a tea party. Keys have been bent in the back door by unseen hands. The little girl could not seem to keep her hands off the toys, as stuffed animals would often fall off shelves with no one around to have knocked them off.

Urban said she hasn't felt her as often as she used to. Part of the reason could be our long run of dry weather. Urban told me that the little girl seems to be more active in rainy weather, as the kinetic energy of ghosts can sometimes be tied to a water source.

Another reason could be that, in the 1990s, Urban had advised the little girl to cross over. Since then, she has not felt her presence.

"I often wonder if that was the right thing for me to do," Urban said. "I kind of miss her at times."

Through the evidence gained from our ghost hunting investigations and from other people's continued encounters with otherworldly spirits on Houston Street, it appears the Little Faceless Girl has not left entirely. Though evidence of her existence was most popularly witnessed in the 1990s and prior, unusual occurrences still tend to happen along the west side of the square. However, whether the Little Faceless Girl really is gone for good, as Ginny-Rea Urban believes, or she simply has decided to stop showing herself to Urban, one enduring and much-publicized mystery remains.

One morning in the 1980s, the former owner of Market on the Square arrived to begin her daily opening duties. At that time, the store contained an old-time photo booth complete with costumes for visitors to dress up as cowboys, saloon girls and other old-fashioned characters before taking their souvenir pictures.

On this particular morning, the owner noticed something odd. Though the Polaroid camera was never allowed to be moved, it was somehow set in a very low position on the stand. No one would have put the camera in this position, as it caused the camera to be quite unstable. In addition to the strange position of the camera, the owner noticed that the antique chair had been moved, and there was a blue dress draped across it. As the other employees entered, the only other people who had keys to the building and would thus have access to the store after hours, the owner questioned them about this bizarre circumstance. Everyone present confirmed that they had no idea what may have happened and that everything had been as it should be when closing the night before.

Portrait of the Little Faceless Girl found inside Market on the Square. *Courtesy of Melba White.*

The mystery deepened as they were straightening up the unusual mess. A photo was found in the wastebasket picturing a little girl sitting in the very chair that had been moved, wearing the same blue dress that had been found, posing for the camera. In her hair was a bow and in her hands was a bouquet of flowers, neither of which had ever been or would ever be present in the store.

Years later, when the visitor staying upstairs saw this picture, he confirmed immediately that she was without a doubt the little girl he saw standing by his bed. The obvious giveaway, of course, was that while the photo was completely clear down to the most minute detail, the little girl, somehow, did not have a face.

CHAPTER 8

B.M. ESTES

THE ESTES BUILDING

I t is not uncommon for business owners to be so proud of their handiwork that they do not want to leave, even if death forces them to do so. Such is the case of Bevly Memphis Estes, for whom the B.M. Estes Building, located at 201 North Houston Street, is named. The B.M. Estes Building was erected in 1893 for the prominent attorney and county judge. It is an imposing building that dominates the northwest corner of the square. It is perhaps best described in the article "A Historical Tour Around the Square" found on the website for the Hood County Historical Society: "This red brick and stone building portrays Romanesque Revival features in stone archways, corbel table, round arch windows and distinctive cast iron exterior stairway."

Bevly Estes's law firm was located on the second floor of the building, while the bottom floor operated as Sam Ferrell's Grocery Store, reportedly a popular location for the men of the area to gather and play poker. In fact, at one time you could even see the burns in the original hardwood floor that had resulted from the poker players' cigarettes falling to the floor and burning themselves out.

Estes was known as an active prohibitionist, and through his efforts on the cause's behalf, he soon found himself elected as a city councilman and then later served as mayor of Granbury. He was known to be very opinionated. Some may even have called him eccentric, though he most certainly was a forward thinker for his time. He believed that women should be educated and demonstrated this by sending two of his daughters to college. He was even known to argue against forcing women to ride their horses sidesaddle.

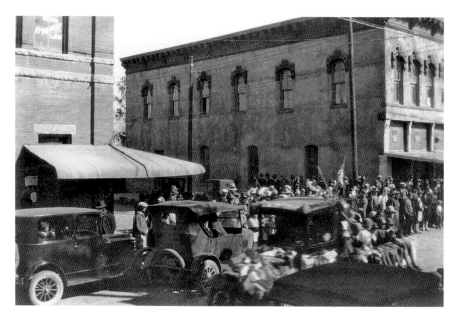

A parade on Bridge Street, circa 1925. The B.M. Estes Building is on the left with the First National Bank on the right. *Courtesy of Laurel Pirkle.*

He loved his building and his position in the community, so much so that even upon his death, he was not ready to leave them behind. In fact, throughout the years following his passing, the presence of Bevly Estes has been felt, and even witnessed, countless times. Cindy Hyde, owner of a clothing store that was located in the B.M. Estes Building for fifteen years, recounted for me just a small sample of what she experienced during her tenure minding the store.

While the building housed Cindy Hyde's rustic clothing store known as Dakota's Kabin, Bevly Estes made sure to remind her on a regular basis who originally owned the building. At one point, the store sold a deck of playing cards featuring the state of Texas on the front cover. These cards were located at the very front of the store to entice customers out of their money and into a purchase.

On more than one occasion, Hyde would enter the store to begin her workday and notice something was a bit out of place. The playing cards, no longer resting by the front counter, were now to be found stacked on top of each other in the middle of the floor of the hallway toward the back of the store.

Was this the result of the popular poker games that had taken place inside the store in years past? Did Bevly Memphis Estes possess a bit of a gambling

streak? Or because of his staunch aversion to alcohol, did he abhor card games as well and was attempting to thwart the sales of these instruments of evil?

Bevly Estes was apparently very particular in his tastes in music. Cindy Hyde decided to experiment at Dakota's Kabin by installing a music listening station along one wall of the store. This station came complete with headphones attached to the wall so customers could sample their music before deciding whether to make a purchase. The music was strictly western in flavor, mostly classic country in particular.

If Estes did not like alcohol or gambling, he most certainly did not appreciate the type of disruption that this music brought to his calm, and he made sure everyone knew it. He decided to take his aggression out on the most tangible object of the listening station: the headphones themselves. While Hyde, her employees and her customers would be standing by the front counter, they would all be suddenly startled by a loud noise. They were shocked as they simultaneously witnessed the headphones sailing through the air, having been flung by an unseen hand, using a force so strong that they were literally ripped from their attachment to the wall.

Tonya Adams, a manager at Dakota's Kabin, witnessed this headphone debacle firsthand as her initial encounter with the ghost. While she was sitting at the computer getting some work done, she had a clear view of the listening station directly in front of her. On more than one occasion, Adams would witness one of the headphones move straight out from the wall as though carried by unseen hands and then suddenly drop to the floor. This would shortly be followed by the second set of headphones following suit. What a relief it must have been for Estes when the store decided to forgo the music listening station entirely in favor of other merchandise.

Tonya Adams told me of another employee's eerie encounter as well. Inside Dakota's Kabin, some of the merchandise included small signs that you could hang on a doorknob. These door hangers would find cute ways of saying "Do Not Disturb," such as "Little Buckaroo Sleeping" and the like. The signs were not designated to simply one central section of the store. Instead, they were hanging sporadically throughout the entire store as a way of enhancing the decorative aspect of the merchandise.

An employee entered the store one day, alone in the building. Brief movement caught the corner of her eye. She turned to find that one of the door hanger signs was swinging back and forth from its hook. She then let her gaze drift slowly across the aisles of the rest of the store. To her shock, every door hanger throughout the store was swinging on its own as well,

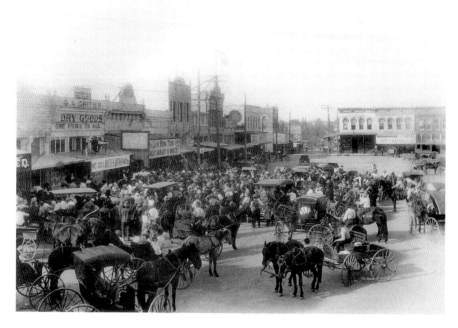

Buster Brown visiting Houston Street, circa 1917. The Estes Building is at the far end of Houston Street, near the center of the picture. *Courtesy of Laurel Pirkle.*

though there were several feet in between each sign, and nothing else on the shelves appeared to be moving or had even been disturbed recently.

Throughout the many years of spending countless hours inside the B.M. Estes Building, Cindy Hyde only truly found herself really spooked just once. It happened late one night as she was closing the store. All her employees had left for the evening, and she found herself all alone. She was on the second floor in the hotel portion of the building above the store, the floor of Bevly Estes's employment and where he also lived for a time.

Hyde was talking on the phone to a friend, not thinking about the unseen residents of the building who were accompanying her and did not want to leave. Suddenly, from downstairs she heard the unmistakable sound of the back door opening, along with the notification bell hanging over the door tinkling in alarm. These two sounds were followed by the heavy footsteps of a person deliberately stomping down the hall as if determined to reach a destination.

Slightly shaken, but ultimately assuming it was merely one of her employees returning to retrieve a forgotten item, Hyde made her way downstairs, making sure to remain on the phone all the while as an added note of precaution.

"Hello?" she called nervously as she stepped through the dark. "Is anyone there?"

Silence was her only response, and she shared her space with only darkness. Hyde implored her friend to remain on the line with her, as she was much too frightened to make it out of the building and to her car alone.

Bevly Memphis Estes seems to like to travel all over the building. The B.M. Estes Building is very large and formidable, and at one time, two separate stores were located inside it. Next to Dakota's Kabin was another clothing store known as the Clothes Horse. Store employee Sydney Carder had a rather unnerving experience while working the register one afternoon.

Carder and a co-worker were alone inside the store on a slow day. The co-worker decided that this downtime was the perfect opportunity to go next door to Dakota's Kabin and fax some documents. She walked out the door, leaving Carder alone in the store by the front counter. Shortly after, the silence was broken by a very loud and very specific sound. From the sale section located all the way in the back of the store, on the completely opposite side of the store from where Carder was working, came the very distinct sound of clothes being separated on the rack, the metal clothes hangers screeching shrilly against the steel of the bar.

Carder looked up suddenly, positive that her imagination was playing tricks on her. Just to be sure, she crept slowly to the back of the store. When she reached the sale section, she discovered that the clothes were, indeed, separated on the rack, a large open gap staring at her in between the half-priced jeans and clearance sweaters.

Carder was slightly shaken but retained her composure, sure that her co-worker had simply slipped back in unseen and was doing some light rearranging. At that moment, the very same co-worker walked through the back door, having just finished her faxing next door.

"Were you just back here?" Carder asked her.

"No," her co-worker replied. "I just told you I was going next door to fax, remember?"

After that incident, Carder had a difficult time working in that back section alone, and she most certainly was never caught in there with the lights off.

Overnight guests of the hotel upstairs often received an experience beyond a normal night's sleep. One morning, Cindy Hyde arrived early to begin opening up her store for the day. Down the stairs came one of her guests, a lady in a group of four who were the only ones renting the hotel

at the time. The guest approached Hyde and inquired if anyone else had in fact checked in overnight. Hyde, bewildered, told her no.

"Are you sure?" the lady pressed on. "There isn't anyone else staying upstairs but us?"

Hyde assured her that no, she and her companions had the upper floor to themselves. The guest suggested that perhaps they were not quite as alone upstairs as Hyde believed. During the night, all four guests simultaneously heard a door to another hotel room opening and closing. This was accompanied by footsteps and the sound of someone rolling a wheeled suitcase down the hall. Was this Bevly Estes or perhaps some wayward traveler simply seeking a place of rest for the night?

Inside one of the suites of the hotel above Dakota's Kabin, a mounted leopard gazed across the room. This leopard always faced the same way and was never moved, especially due to the fact that it sat at the very top of a tall television cabinet. In order to even touch the cat, one would need a stepladder to reach to the correct height.

Tonya Adams entered the room one day and was struck with the notion that something was not quite right. While the room looked neat and orderly, she could not shake the feeling that something somewhere was out of place. That was when she spotted it. The stuffed leopard, which no one would have any cause to touch, was now facing in the complete opposite direction.

The hotel above Dakota's Kabin was a popular destination for wedding guests, honeymooners and simply those seeking a romantic getaway. One guest of the hotel wanted to prepare a surprise for his special lady. He placed an order for flowers and wine to be delivered to the hotel and requested that Dakota's Kabin employees place them in the room to surprise his wife.

When the wine was delivered, an employee promptly retreated upstairs to place the bottle in the room. Upon arrival to the room, the young lady was startled to find the television had been turned on. Assuming the cleaning lady had merely been careless in her duties and had left it on when she had finished for the day, the employee shrugged it off and powered down the television.

Not long after, the flowers arrived. The same employee made the same trek back up the stairs to arrange the flowers along with the wine. When she opened the door to the room, the television once again was blaring. Shaken, the employee swiftly fled the room, at which point she ran down the stairs to Tonya Adams, to whom she explained the situation. Refusing to go back to that room, she thrust the flowers into Adams's hands. Adams went up to the room herself to complete the request of her guest. When Adams entered the

room, she confirmed that the television was in fact running. Bevly Memphis Estes may not like western music, but he does seem to like watching sitcoms.

In fact, Bevly Estes may not be the only spirit residing in the B.M. Estes Building. Years ago, Cindy Hyde was contracting some construction work on the interior of the building. One evening, a construction worker brought his girlfriend in to keep him company while he worked. While spending time with her boyfriend, the woman got the distinct sensation of a little girl in the room as well.

Ordinarily, something so vague as a general sense of a presence could possibly be chalked up to an overactive imagination or just a simple case of the heebie-jeebies. However, this woman was getting a more exact feeling: the feeling that this little girl died when she fell from a landing high along an interior side wall of the building. This landing did indeed exist; however, it had been removed long before the woman's construction worker boyfriend had ever set foot inside the building, rendering it virtually impossible for the woman to know the previous architecture of the building.

Perhaps Bevly Estes's fatherly intuition comes out with this little girl as well. He did, after all, support his own daughters in reaching their full potential.

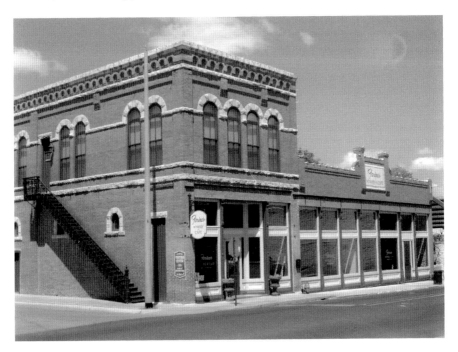

Present-day exterior of the B.M. Estes Building, renovated into Farina's Winery and Café. *Author's collection.*

Cindy Hyde and her other employees would sometimes try to test the spirits of the building. They would leave out a pair of scissors in a predetermined location, with everyone under orders not to move them. Later, when they would return to the building, the scissors were almost always moved to a different area from where they had originally been placed. Perhaps Estes is seeking to protect the girl and is attempting to ensure that she does not cut herself on such a sharp object!

I even have my own personal ghostly experience that happened at the B.M. Estes Building. When my mother and I began the Granbury Ghosts and Legends Tour in April 2010, we wanted to make sure the shop owners were aware of what we were doing in order to avoid alarming anyone. The weekend before the inaugural night of the tours, we moved through the downtown square, traveling door to door to alert the shop owners and their employees as to what would happen beginning the next week.

We walked into Dakota's Kabin and made our way up to the front counter. I approached the employees and introduced myself, saying, "Hello! I just wanted to let you know that starting next weekend, every Friday and Saturday night we will be conducting ghost tours around the square."

It was at this exact moment, the second I finished speaking, that our eyes were immediately drawn to a swift movement off to the side. Though no one was standing next to the wall, and no one was walking across the floor to cause any merchandise to become jostled, a cowboy boot on display on the side wall somehow flew off the wall and landed about eight feet away from its shelf.

When I say "flew," I want to make it perfectly clear that I mean "flew." It did not simply fall off the shelf and slide. It was on a straight trajectory as if someone had literally thrown it or at the very least given it an extremely hard shove.

An employee laughed and said, "Well, there is our ghost right there!"

Shoppers inside the store were calling their friends from the back of the store to come and see what had just happened. "This woman was just talking about a ghost tour, and a boot just flew off the wall!" they called to their companions.

Some even went so far as to take pictures of the boot itself as it lay, once again motionless, on the wooden floor several feet away from the shelf where it had been resting only moments earlier. I like to think it was Mr. Estes voicing his approval of the tours and wanting to make sure we did not leave him out! Of course, we sometimes get the occasional wisecracker who suggests perhaps Estes is "giving us the boot," but I prefer to remain an optimist.

Bevly Estes also received a bit of company one evening when his presence was requested by Research and Investigation of the Paranormal. The group members came in for a late-night ghost hunting experience, setting up their cameras and electronic voice phenomena recorders, hoping to make contact with the esteemed man about town. The evidence they received resulted in mixed messages. Did Estes welcome his guests, or were they interrupting his precious rest?

One audio recording they received would suggest the latter. From one of the EVP recorders they had placed upstairs, they received the recording of a man's voice saying, "Leave me alone!"

Boots were flying off shelves in a similar experience to my own earlier supernatural incident in the building. Wind chimes were repeatedly clanging together as though someone had hit them with his hand. RIP co-founder James Leslie encountered some difficulty in his attempts to open doors upstairs. Leslie would go to open a door that had just opened easily moments before only to find he was now shut out. His attempts to turn the doorknob went unrewarded as it felt as if the knob was being held firmly in place on the other side of the door.

First Sergeant Gregory Stephens, the other co-founder of the group, experienced a bit of unpleasantness when he began to address Estes directly in the hope of engaging him in an interaction. From a display of small decorative rocks on the opposite side of the aisle came a stone hurled as a missile toward Stephens. Bevly Estes was in no mood to talk.

Or was he? Other evidence gathered in that same investigation may have suggested otherwise. Tonya Adams accompanied the group during the investigation of her place of employment. The question was put to Bevly Estes, "Are you standing next to Tonya?"

The reply over the recorder was a resounding, "Yes."

It was not said in a threatening way but merely as a casual response to a question, as if he did not mind that Tonya was there near him.

Tonya Adams's mother, Pam Adams, encountered Bevly Memphis Estes's hospitality personally. Joining her daughter on the ghost hunt with Research and Investigation of the Paranormal, the mother-and-daughter team found themselves standing inside the dark building, unable to see even a few feet in front of them. The darkness disoriented them both and made them question their equilibrium.

Suddenly, Pam Adams felt something firmly against her back. Because of the confusing nature of the darkness, she merely assumed she had leaned too far back and was now leaning against one of the shelves. To test this theory,

she took a full step backward, only to encounter no shelving or walls directly behind her. Soon after, Adams felt another presence at her back. "Surely I must be very close to the shelves by now after that step back!" she thought.

She took another step back and still felt only empty space. Her nerves became even more rattled when she felt the touch against her back for a third time. Trying once more to calm her fears, she took one more step back. Once more confirming that she was nowhere close to anything being able to touch her, Adams could stand it no longer and broke her silence.

"Something is here!" she called to the investigators. "It just touched my back three times!"

The audio recorder placed on the downstairs floor of the building caught an interesting bit of vocalization as well. At one point in the recording, a man's whistling could be heard over the speaker. This was not merely an atonal high-pitched noise, either. The whistling was clearly of a tune, almost sounding like the theme song to the classic television show *Gilligan's Island*, in fact. The sound faded and rose at a regular pace, as if the whistler was casually strolling back and forth in a pace across the floor. This does not sound like the actions of a man who is perturbed by the thought of intruders into his personal space.

However, it was one act of what can only be described as sheer politeness that leads me to believe that he may not mind sharing his occupancy with other guests. During the investigation, the air conditioning was turned off, as is customary in any investigation in order to reduce interference with the audio recorders. Considering the fact that this is located in Texas and that the investigation did not take place during the winter, suffice it to say that even at night, turning your air conditioner off can make things very warm very quickly.

Members of the investigation team were inside the building and began remarking about just how hot it was for them inside. Abruptly, in direct response to the group's complaints, the air conditioning turned on by itself in Estes's attempt to bring comfort to his guests. Even if all he wants is to be left alone, at least Bevly Estes is still polite when he is entertaining company.

Bevly Memphis Estes even seems to be quite helpful. Sydney Carder was once a resident of the B.M. Estes Building, living upstairs above Dakota's Kabin for about eight months. One day, she found herself confined to her bed, horribly ill, with a dangerously high fever.

Suddenly, a knock rapped heavily on her door. Carder was not expecting visitors, nor did she have any desire to speak with anyone. She was too sick even to get up and answer the door, let alone entertain any guests. She

decided instead to simply ignore the knock, hoping the visitor would take the hint and come to see her again when she was well. She closed her eyes and began to drift back off to sleep.

She was just on the verge of slumber when she unexpectedly felt an unseen hand touch her leg. Her eyes flew open, scanning the room to search for this bold intruder. No such intruder was found. She was still alone in the room, as she had been the entire time. She was unnerved, and she finally drifted back to a restless sleep, all the while wondering just who or what had touched her leg.

Apparently, her visitor was a welcome spirit intent on helping those in need. Merely an hour later, though she had been terribly sick all day with no relief in sight, the fever broke, and Sydney Carder made a full recovery. Since then, though Carder had often found herself unnerved by the ghostly encounters inside the B.M. Estes Building, she never again felt frightened anytime something unexplained occurred. The ghost that lives there "is obviously something good," Carder said.

Carder received word of another possible ghostly encounter from a co-worker's son. While waiting for his mother to end her shift for the day, the son and his friend were spending time in the living quarters upstairs. They set a drink down on a side table in the hallway next to the door to one of the apartments. Upon returning to that area moments later, they were amazed to find that their drink had been moved and was no longer in the location where they had just left it. No one had been on the upstairs floor for the duration of the boys' visit, yet somehow the drink had been displaced. Perhaps Bevly Memphis Estes was concerned about water rings damaging his table?

After Dakota's Kabin and the Clothes Horse were closed, the building was renovated into Farina's, a restaurant and winery with an accompanying bed-and-breakfast upstairs. The ghostly experiences did not die with the retail stores; employees of Farina's have experienced some unexplained circumstances as well.

Charlie Shearing, a server at Farina's, was helping to advertise the refurbished bed-and-breakfast accommodations. She was putting her photography skills to good use, taking photos of the various suites to later be used for promotional purposes. While snapping photos of what they dubbed the "Jesse James Suite," Shearing heard a sudden noise near the side of the bed.

She described it to me as if something had fallen off the nightstand and was then scraping across the hardwood floor as if dragged by phantom

hands. Shearing is also uncomfortable going inside the bathroom located in the Jesse James Suite. She says the bathroom gives off a very dense feeling, as if the air is thick and muddled.

Farina's server Mandy Jenkins had a prolonged encounter with the ghostly resident. As Bevly Memphis Estes wanted to help Sydney Carder overcome her illness, so did he also wish to aid Jenkins as she went about her workday.

One day, Jenkins had the job of cleaning the rooms of the bed-and-breakfast upstairs. She wanted to get done with her job quickly so she could resume her regular duties, and she was hoping to get upstairs in a flash. As she was thinking this, she stepped into the elevator. The elevator door is on a timer; thus, anyone wishing to use the elevator must wait a predetermined amount of time before the door will close and the elevator will begin to move. However, at this particular moment, the elevator door closed immediately after Jenkins entered the mechanism and delivered her directly to her third-floor destination.

Startled but pleased with the result, Jenkins commenced with her job for the day. She began cleaning the Renaissance Suite, wearing headphones to keep herself entertained while not disturbing anyone else in the building. While going about her cleaning duties, she began to get the very distinct feeling of someone watching her. Becoming self-conscious, she looked up quickly to catch a dark figure out of the corner of her eye. The figure quickly disappeared, and Jenkins shrugged it off and returned to her work.

Throughout the day, however, she was constantly plagued with the feeling that she was being watched. Each time she would attempt to catch the culprit, a shadow would dance in front of her eyes before once again fading into the darkness.

When she finished her work for the day, Jenkins wanted to get back downstairs quickly. Just as she was thinking about how she would like to make a quick exit, the elevator precipitously appeared before her, having been somehow called up on its own. The elevator will only move if the call button is physically pressed. However, this time, somehow it just knew. Bevly Memphis Estes simply wanted to help a tired worker after a long day.

Some Granbury Ghosts and Legends Tour guests believe that Bevly Memphis Estes shares his living quarters with an elderly lady. On several tours led by our other tour guide, Chris "Boots" Hubbard, visitors have taken bizarre pictures through the windows of the B.M. Estes Building.

In each photo, they have found the image of an elderly woman, her face haggard from long years and a difficult life, wearing a deep blue jacket with an old-fashioned pink scarf covering her head and neck. The first time

this occurred, the guest who had taken the picture interrupted Hubbard to show him what her cellphone camera had just revealed. The tour group was struck by this incident, and they patiently waited to see if this elderly lady might come to the front window and make additional contact. When no such contact occurred, Hubbard concluded his story and began to lead the visitors away to the next destination on the tour.

As they began to travel down the street and away from the building, the group was immediately stopped when they could all simultaneously hear the moaning of a woman from an upstairs window. When they turned back to stare at the building in awe, the moaning promptly ceased. The moaning, along with the startling photos taken by visitors, has occurred on several tours since that initial encounter. Could she be someone related to Estes in some way, or is she simply just another of Granbury's early settlers, weary from a rough life on the prairie?

Bevly Memphis Estes was a prominent figure in Granbury's history when he was alive, doing all he could to see the town succeed. Now, even in death, Estes is still a prominent figure in the town. From his name conspicuously displayed on the impressive building that held his office to the regular incidents of current visitors continuing to make his acquaintance, Bevly Memphis Estes assures us all that he will not soon be forgotten.

MORBID AND MACABRE MISCELLANY

THE GRANBURY CEMETERY

If Granbury is known as "where Texas history lives," the town could also be considered where Texas history rests in peace. Granbury's area cemeteries, primarily the Granbury Cemetery and the Acton Cemetery, boast of Confederate veterans, family members of Texas heroes and even legendary outlaws.

Resting high on the hill that used to be part of Granbury's college is the Granbury Cemetery, home to countless past residents of Granbury and Hood County. Located approximately half a mile north of the downtown square at the intersection of Houston and Moore Streets, a trip through the steel cemetery gates is a trip back in time.

You never know what you will find as you stroll along the paths that lead to the various memorials. Interspersed with the elaborate monuments and markers are many graves of a more dilapidated nature, their headstones long since missing. In some cases, the only way to even discern there is a grave located where you are standing is to notice the mounded-over ground covered with rocks and deliberately placed debris.

Several graves are even located in what some refer to as "mummy stones." These graves have no marker at the head of the burial site; instead, they are covered with a stone in the shape of a coffin and bear no inscription thanks to the erosion brought on by time and weather.

The Granbury Cemetery is a tranquil sea of grass, trees and stone. However, there are times when people will swear it is not as tranquil as it should be. Sometimes, the cemetery residents themselves are not resting quite as peacefully as we thought.

The main gate to the historic Granbury Cemetery. *Author's collection.*

The Granbury Cemetery is exceptionally active in the realm of spooks and spirits. In addition to the flashlights dying on the cemetery tours, tour guests have also lost full batteries on their cameras, have had difficulty focusing their cameras or have experienced some other sort of technological malfunction.

This is quite common when spirits are among the living, as the energy of the ghosts tends to mingle with the energy of the technology, causing interesting results. In fact, a guest on one tour was using a popular ghost radar application on her phone. The idea of the application is to show where ghosts are supposedly located, and it will randomly say various words that are supposed to be associated with the nearby spirits. This particular woman was having an extremely difficult time getting the full effect of this application because her phone kept turning the volume down on its own, causing her to have to turn it back up! Perhaps there was a ghost nearby that did not appreciate eavesdropping?

Because of its eerie atmosphere and ready supply of paranormal activity, the cemetery has become popular among paranormal research groups. Our

group, Research and Investigation of the Paranormal, has investigated the Granbury Cemetery on two separate occasions. At any given time inside the cemetery at night, it is not uncommon to catch shadows in the shape of humans running in the distance. I notice this almost weekly on the cemetery tours, and during the ghost hunts, it was no exception.

Gregory Stephens personally witnessed what appeared to be two figures running together. As a first sergeant in the United States Army, Stephens shares a special kinship with many of the residents of the cemetery, as there are a great number of veterans, from the Civil War to present day, laid to rest in Granbury. Stephens decided to see if he could possibly interact with some of these veterans. He stood in the middle of the cemetery and shouted a call to arms. Immediately upon finishing his call, Stephens witnessed a flurry of movement and heard the scurrying of footsteps, as if the soldiers really were mustering into formation.

Investigating the cemetery has led to some curious experiences as well. At one point, while Gregory Stephens was walking in the direction of the most famous resident of the Granbury Cemetery, who we will discuss at length later in this chapter, he distinctly heard whispered in his ear: "Where are you going?"

James Leslie also experienced something rather unusual. Though it is most likely chalked up to mere coincidence, the novelty of what happened is enough to mention here. While Leslie was standing in the cemetery, he simply called out, "If anyone is here and wants to talk, let me know! I am here to listen!"

His eye was immediately drawn to a bit of movement on one of the nearby paths. After determining that the movement in fact belonged to a cat, Leslie shrugged and followed it anyway. After a few minutes of weaving through the headstones in pursuit of the animal, the cat finally concluded its journey by walking up to a headstone, climbing on top of it and promptly falling asleep. The name on the headstone that served as this feline's napping place? Catts.

Ghost hunting can sometimes be dangerous work. After the success of his call to arms, Gregory Stephens decided to try a different tactic that could have ultimately put him in the hospital. Stephens decided to stand under the gazebo, or "workman's toolshed," as it is commonly called, located in the center of the cemetery. He then had the rest of the group spread out throughout the cemetery in groups of two or three to simply observe as Stephens began to shout and provoke the spirits into showing themselves.

Apparently, spirits do not necessarily like being provoked. As Stephens stood in the gazebo, he clearly heard loud footsteps running up behind

him. The footsteps were so heavy and loud that Stephens actually braced himself for the impact he knew was inevitable. There was no possible way that whoever was running up behind him would be able to stop in time from running directly into Stephens's back and hitting it hard. However, no impact ever occurred, at least not right then.

After the ghost was apparently frustrated that he or she was unable to scare Stephens away by threatening to tackle him, the spirit decided to up the stakes by throwing a rock. Luckily, the rock did not hit Stephens hard enough to hurt him; it was simply enough to excite him. I often joke that you know you are a ghost hunter when you actually get excited when someone hits you with a rock, and you ask them to do it again!

At one point during the main provocation that Gregory Stephens was performing, the woman standing next to my mother and me decided to join in the fun. She began to call out, "Come over here and get me! I am a Yankee! Come get the Yankee!"

Knowing the large number of Confederate veterans who are laid to rest in the Granbury Cemetery, my mother and I took a couple steps back from the other woman, in case we happened to get caught in the crossfire. In fact, someone did come get the Yankee. As all the small groups were coming back together following the conclusion of the provocation, the woman reached up and felt two distinct scratches running perfectly parallel to each other down the center of the back of her neck.

Why is the Granbury Cemetery so popular with tourists and ghost hunters alike? Aside from the plethora of unique monuments and markers, many of which date back to the 1870s, the cemetery itself is home to several famous historical figures.

One popular monument on the cemetery tour marks the grave of Major John Bennett Dickson, who served as a veteran of the War of 1812 and was even wounded in the famous Battle of New Orleans under General Andrew Jackson. It is markers like that of Major Dickson that make the Granbury Cemetery such a unique location to spend an hour or two. The following is a mere sampling of the history and mystery you will find in the Granbury Cemetery.

BRIGADIER GENERAL HIRAM BRONSON GRANBURY

The town of Granbury was named after Hiram Bronson Granbury, who served as a brigadier general in the Confederate army during the Civil War.

He was captured on February 15, 1862, and taken as a prisoner of war to Johnson Island Prison at Lake Erie in Pennsylvania. He was later paroled as part of an officers' prisoner exchange.

Granbury was slightly wounded at the Battle of Chickamauga and later killed in action in Tennessee at the Battle of Franklin while commanding Granbury's Brigade. Because his brigade served in the Battle of Franklin under General John Bell Hood, for whom Hood County is named, and because Brigadier General Granbury fought so valiantly in battles across the South, it was decided to name the county seat in his honor.

Hiram Bronson Granbury was originally buried in Tennessee following his death. However, in November 1893, through the concentrated efforts of several of Granbury's notable residents at the time, General Granbury's

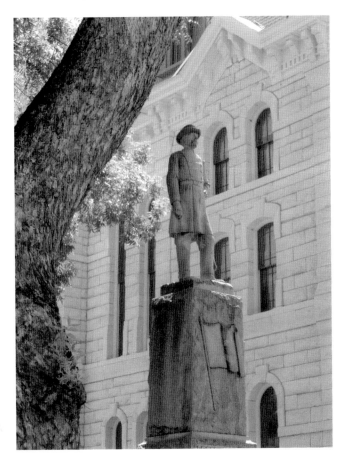

Brigadier General Hiram Bronson Granbury's statue next to the Hood County Courthouse. *Author's collection.*

remains were reinterred in the Granbury Cemetery amid great fanfare and celebration. His grave is not the only location to hold a marker erected in his memory. Visitors to Granbury's square can also witness General Granbury himself towering over them from his pedestal next to the courthouse with a marker that reads, "Erected by the U.D.C., General Granbury, Chapter No. 683, In memory of Brigadier General H.B. Granbury and his Valiant Followers. Granbury 1861–1865."

Next to Brigadier General Hiram Bronson Granbury stands a marker for his wife, Fannie Sims Granbury. She married General Granbury in 1858 in Waco, Texas. She was a devoted wife, wishing to travel with General Granbury throughout the war in an effort to remain close to him. Sadly, this effort did not last long.

Shortly after General Granbury's parole from prison, his wife was diagnosed with inoperable ovarian cancer with only months to live. On March 20, 1863, Fannie Sims Granbury succumbed to her illness at only twenty-five years of age. She was buried in an unmarked grave in Alabama, where she remains to this day.

Grave site for Brigadier General Hiram Bronson Granbury alongside a marker for his wife, Fannie Sims Granbury. *Author's collection.*

We unfortunately know little about Fannie Sims Granbury besides her relationship with her husband. When Brigadier General Hiram Bronson Granbury passed away, all memories of his wife died with him, and they had no children to carry on their legacy. Because of the deep love Hiram Bronson Granbury shared with his wife, a marker was later erected next to his in her honor to show that while she may never be together with her husband in body, she will always remain with him in spirit.

THE CROCKETT FAMILY

David Crockett was not only a true Texas hero, but his great deeds at the Battle of the Alamo have elevated him to legendary status. It is difficult to find anyone who hasn't heard the "Davy Crockett" song. Even today, children are still being taught the song in schools. Because Granbury is quite the legendary town itself, it only stands to reason that his family might eventually wind up here.

In the 1850s, David Crockett's widow, Elizabeth, migrated to Texas along with George Patton, her son from her first marriage, and his family; her son Robert Crockett and his wife, Matilda; and her daughter Rebecca Halford and her family. Due to her husband's valiant efforts at the Alamo, the State of Texas awarded her land as compensation. The land she received was in the Granbury area, making her one of the earliest settlers of Hood County.

Although the land they obtained was not the most suitable for farmland, Elizabeth Crockett was a determined woman with a keen intellect for business and farming, and she and her family set about building two log cabins and creating a farm.

Elizabeth Crockett passed away in 1860 at the age of seventy-two after an early morning walk from her cabin. She is now buried in the Acton Cemetery, in a small community about six miles from downtown Granbury located on Fall Creek Highway, where her grave site, not the cemetery itself, marks the smallest state park in Texas. In the brief biography compiled by Kenneth Hendricks, a direct descendant of David and Elizabeth Crockett, he states, "Her statue above the grave shows her looking to the west, eyes shaded, waiting for her husband to come home from the War."

The Crockett family's fame in Granbury did not end with Elizabeth Crockett, however. Her grandson Ashley Crockett, son of Robert and Matilda Crockett, would soon mark his place in Hood County history as

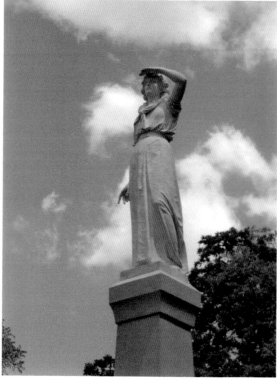

Above: The site of the smallest state park in Texas: Elizabeth Crockett's grave site and monument at Acton Cemetery. *Author's collection.*

Left: Statue of Elizabeth Crockett searching for her husband, David, at Acton Cemetery. *Author's collection.*

FAMILY OF
A SHLEY W. CROCKETT
GRANDSON OF
DAVID "DAVY" CROCKETT

Grave marker for Ashley Crockett and family at Granbury Cemetery. *Author's collection.*

well. Ashley Crockett was born with an opaque film over one eye, and because there was no doctor present to immediately mend the condition, he was resigned to living his life with visibility only in his other eye.

When his father advised him that his lack of proper vision would hinder his ability to become a farmer, Crockett set his mind to following a different profession. At thirteen years of age, he moved to Weatherford and obtained a job as a "printer's devil" with the *Weatherford Democrat*. When he reached eighteen, after having fully learned the art of printing, Crockett returned to Granbury and secured a position with Granbury's first newspaper, the *Granbury Vidette*. Just a few years later, Crockett became sole owner of the paper and then promptly changed the name to the *Granbury Graphic*.

That newspaper is still in operation today under the name of the *Hood County News*. The building that houses the newspaper boasts a historical marker, thanks in part to Ashley Crockett's efforts. Ashley Crockett and his family are now buried in the Granbury Cemetery, just a few plots down from Brigadier General Hiram Bronson Granbury, and his grave remains a popular stop on the cemetery tour.

WILLIAM HENRY HOLLAND'S ARM

William Henry Holland may not be found in any history textbooks. He is, however, worth mentioning in this book purely for the oddity he presents at

The arm of William Henry Holland is located inside the center tomb at Granbury Cemetery. *Author's collection.*

the Granbury Cemetery. In a story straight out of Fannie Flagg's *Fried Green Tomatoes*, William Henry Holland, son of one of Granbury's earliest settlers, is the owner of an arm buried by itself in its own special tomb.

According to Holland's half sister, Amanda Elizabeth Holland Galik, Holland fell from a pecan tree when he was thirteen years old and broke his arm. His arm was amputated three separate times in order to combat blood poison and was finally laid to rest in the Holland family plot in between the tombs of infants belonging to the Holland family.

The story of an arm buried in the Granbury Cemetery is unusual in and of itself. However, the story becomes rather remarkable when it becomes related to the grave of our most famous, and notorious, resident of the Granbury Cemetery.

JESSE JAMES

Among its many claims to fame, Granbury also seems to be a town where outlaws turn up after they were allegedly killed. If John Wilkes Booth could

perform at the Granbury Opera House after the incident in the barn in Virginia, why can't Jesse James die in Granbury almost seventy years after he was shot by Robert Ford? The popular historical rendition is that Jesse Woodson James was killed in 1882 by Robert Ford, a member of his own gang, who shot James in the back in order to collect the reward money. That should be the end of the story, right?

According to local Granbury legend, fueled by some of Jesse James's descendants themselves, the story was really only beginning in 1882. Ola Everhard, who claims to be the third cousin of Jesse James, spoke to the *Albuquerque Journal* in an article published in 1983, a little over a century after James's first death. Everhard maintains the belief that the correct Jesse James is found in the Granbury Cemetery after he perished in this town in 1951.

Ola Everhard believes that Jesse James's death was staged in an elaborate conspiracy that even involved Thomas Crittenden, then governor of Missouri. By her account, the person killed by Robert Ford was in actuality a man by the name of Charlie Bigelow, and it is Bigelow's body that remains in James's grave in Missouri. She says Jesse James himself even attended his own funeral, serving as Bigelow's pallbearer under the name Frank Dalton!

How would they be able to pull off such an elaborate hoax to convince the world that Jesse James had died and even elicit the help of the governor himself? Money, of course. Thomas Crittenden had made loud proclamations, promising the public that he would rid the area of notorious outlaw gangs, with the James gang high on his list.

Unknown to Crittenden at the time, Jesse James made numerous anonymous campaign contributions totaling $35,000. The night before the alleged assassination, James met with Crittenden and revealed what he had done. The very next day, Charlie Bigelow was assassinated and buried

shortly after, with no death certificate ever being issued. The only proof of Jesse James's death was Thomas Crittenden's word.

Following the death, Robert Ford received his $10,000 reward money along with an immediate pardon from Crittenden for his actions. Reportedly, however, a portion of that $10,000 bounty was returned right back to Crittenden himself.

Jesse James was now a free man. Where would he go, and what would he do? James, again under the alias of J. Frank Dalton, took up a job working the railroads, thus ending up in Granbury. According to Hood County sheriff Oran C. Baker, who befriended the man claiming to be Jesse James shortly before James passed away, while James spent time in Granbury, he met the woman who would become the love of his life, the daughter of James's railroad co-worker. In fact, she is the very reason why James returned to Granbury years later in 1951 to die. James told Sheriff Baker, "She died and was buried in Hood County, and my desire is to die and be buried here."

Jesse James's confession to Sheriff Baker of his true identity left such a mark on the sheriff that he revealed this story in a 1966 article for the *Hood County News-Tablet*. Sheriff Baker affirms at the end of the article, "From what I have learned about Jesse James from child hood [*sic*] and from my examination of the body at the funeral home, I would say that I firmly believe this man to be the one and only Jesse Woodson James, 107 years old."

Please note, while the article states that James was 107 years old at the time of his death, the dates on his headstone add up to reveal he was actually 103 years old at his passing.

Sheriff Baker also reveals in this article the results of the postmortem examination of the body over which he presided. He claims to have personally counted thirty-two bullet wounds throughout the body, a rope burn scar around his neck, terrible burns on his feet and the missing end of an index finger. If this man was not actually Jesse James, he certainly had a hard enough life otherwise!

The man claiming to be Jesse James died in Granbury on August 15, 1951, about nine days after his arrival to the town with his grandson. He was laid to rest in the Granbury Cemetery with a headstone that reads, "Jesse Woodson James, Sept. 5, 1847–Aug. 15, 1951, Supposedly killed in 1882." He is by far our most popular resident of the Granbury Cemetery, a distinction worthy of markers leading visitors directly to the location of his grave.

It is quite common for visitors to his grave to notice a large abundance of pennies and coins covering his headstone. This apparently stems from an old custom where friends of the deceased would place pennies on a person's

Grave site of Jesse Woodson James at Granbury Cemetery. Note the large number of coins covering the marker. *Author's collection.*

headstone as a way to try to buy his way into heaven because they fear he would not reach the destination otherwise.

Another theory behind the coins was presented to me by a guest on the Ghosts and Legends Tour. She had heard from a friend of hers who lived in Missouri that the name "Jesse James" was quite synonymous with coins there. He was known to have thanked a gracious host after a satisfying meal by leaving a coin as a tip directly underneath his plate. This was a type of calling card; people would realize their guest had been none other than the notorious Jesse James after he had left and they had cleared the table, discovering the solitary coin left behind in gratitude.

Both theories sound equally valid. Whether the coins are left as payment for salvation or for a gentle nod to James's own personal custom, there is never a shortage of coins to be found on his marker in Granbury. Visitors to this day still pay respects by laying coins on his headstone, as well as a number of other objects, including bullets, cowboy boots and the occasional flask of Jack Daniels.

In fact, a rather unusual encounter involving the coins on Jesse James's grave occurred during one of our cemetery tours. Tour guide Chris "Boots" Hubbard filled in for me on the cemetery tour one night as I had the evening off. Earlier in the day, Hubbard had stopped at the Granbury Cemetery to pay his respects to the famed bandit. With the precise attention to detail that only Hubbard does best, he took the time to count the number of pennies covering the headstone, with the total reaching sixty-eight.

Later that evening, Hubbard led the tour to Jesse James's grave and began his story. As he glanced down at the grave during his recounting of James's time in Granbury, something startling caught his eye. Though he had been out to James's grave no more than five hours earlier, the coins adorning the marker had altered dramatically. There were now well over one hundred coins on the grave, and not simply pennies anymore.

As Hubbard told me, "One rather worn quarter, two dimes and sixteen nickels, along with an increased number of pennies, were all aligned to spell out the words, 'I Love You, J.J.' In my estimation, it would have taken someone quite a bit of time to rearrange the coins and to make this pronounced statement of affection."

Hubbard went on to conclude, "Perhaps the love of Jesse's life returned to add more coins and spell out the message of love on top of the grave site."

The burial of Jesse James does not mark the end of his story, however. Many years later, amid all the controversy over whether the man in Jesse James's grave in Granbury really is Jesse James, an exhumation order was finally signed to test his DNA. As excited followers eagerly waited to learn the results once and for all, it was quickly determined that they had, in fact, exhumed the wrong man.

This blunder was made painfully obvious when it was discovered that the man they had exhumed was in possession of only one arm. Because of this revelation, the descendants of William Henry Holland, the man whose arm is buried separately in the cemetery, were able to rebury their ancestor with a proper headstone. The consensus was that Jesse James's headstone was placed over the wrong plot, but as of the time of this writing, another exhumation order has not yet been issued to try to find the right one.

Only in Granbury, however, can an already odd story of an arm buried by itself in the cemetery become even more bizarre by being linked to one of the most notorious outlaws in history!

CONCLUSION

What is a ghost? That is the question that has plagued students of the supernatural for centuries. Why do people linger after they have passed on? Is there any indicator that might help us to know whether or not a place is likely to be haunted? Why is one place more likely to be haunted than another?

There are multiple types of ghosts and hauntings that can occur. Three of the most common forms of paranormal activity are residual hauntings, poltergeist activity and intelligent/interactive hauntings. Almost all the hauntings found in Granbury that were mentioned in this book can be explained by those three definitions.

A residual haunting is literally the lingering of energy in any given location. The haunting is like an imprint of what has transpired there in the past. The spirit will not interact with the living; it is merely re-creating events that have taken place. Hearing footsteps or voices of people who are not there is common with a residual haunting. This could be what Kay Collerain at the Nutshell Eatery & Bakery experienced when she heard phantom conversations from the floor below her. It could also explain why Coletta Henderson would see Mary Lou Watkins walking up the stairs at the Nutt House Hotel from time to time or why Bevly Estes was heard pacing and whistling a tune. At these moments, a scene is merely replaying itself, and witnesses are nothing more than a captive audience.

Poltergeists are mischievous and playful spirits. They are generally linked to a person or a place, and they love attention. The Lady in Red from the Nutshell Eatery & Bakery could possibly be considered a poltergeist. She is

most certainly tied to that location, and boy, does she cause mischief! Throwing kitchen items, hiding the food and the paintbrushes and playing with the radio are all indicators of psychic manipulation caused by a poltergeist.

When items fall off shelves or the playing cards are moved at the B.M. Estes Building, that could also be indicative of poltergeist activity. Possibly even lonely Joe at the Historic Hood County Jail could be considered a poltergeist, as he seemed to be somehow drawn to Bobbie Jordan in particular, even going so far as to sit on her lap. Krewa at the Granbury Opera House is another great example of a poltergeist. He found himself linked with Carol Cooper and took it upon himself to make her notice him. Think of a poltergeist as someone who is throwing a temper tantrum. The person throwing the fit simply wants attention, and he will do all he can to get it.

It seems the most common presence on the historic Granbury square is, interestingly enough, an intelligent or interactive haunting, especially evidenced through the extensive ghost hunting investigations that have taken place. An article written by Paul Dale Roberts on the True Ghost Tales website gives an excellent and fascinating definition for intelligent hauntings:

> When our mortal form dies, the aura that constantly surrounds our bodies leaves our bodies. We lose 6 ounces on the instance of death. What is this 6 ounces? Perhaps it is energy leaving our body. Our soul. This energy, the aura, or you may even call it your soul, is carrying the information of what we used to be. If it can do this, then why couldn't it also carry our intelligence? If it can carry our former intelligence of our previous life, then it should be able to interact with us intelligently. When we see this aura, we call it a ghost.

Most of the ghosts found in Granbury appear to actually interact with the living, the most obvious being Audrey at the Langdon Center, of course. Audrey loves the attention brought to her by the ghost tours and the paranormal investigations, but she does not act disruptive in order to get it. In fact, interacting with Audrey is very similar to interacting with any living child. The only difference is that you have to wait to review the tapes later in order to realize she really has responded to what you said, making it difficult to fully engage her in real time.

John Wilkes Booth/John St. Helen could also be an intelligent haunting. When provoked by the members of Discovery Channel's *Ghost Lab*, he responded with a direct answer to their question of his identity. Intelligent hauntings simply are spirits that are using their energy to consciously interact with the living world around them. Think of it as having a visitor that you cannot see.

The main haunting found on Granbury's square that leaves me rather baffled is that of the Little Faceless Girl on Houston Street. She almost seems to be all three kinds of hauntings rolled into one. The visual sighting of the little girl who did not interact with the man himself and the discovery of the child's gloves could be indicative of a residual haunting. Throwing the toys off the shelves and playing with the tea set could be the result of poltergeist activity.

Yet how do you classify the portrait she left behind? At first thought, my mind seems to go toward an intelligent haunting. She had to consciously interact with the camera to reposition it and make it take her picture. She also had to move the chair and adorn herself in the blue dress before leaving it behind, draped across the seat. That must undoubtedly point to an intelligent energy.

However, how do you explain the bow she was wearing in her hair or the flowers she held on her lap? Neither of these items was found inside the store, suggesting that she brought them with her and took them back when she left. Could the portrait incident then somehow be described as a complicated combination of a residual and an intelligent haunting?

Perhaps the old-fashioned camera reminded her of the cameras that used to take her picture during her days with the circus. And perhaps the blue dress reminded her of a dress she used to wear. Remember that she was spotted wearing a green skirt. Then perhaps the residual energy of the Little Faceless Girl happened to coincide with the actual items reminiscent of her past, and the result left the astounding image that was later found discarded in the trash can. Or perhaps I am simply reading too much into it.

At the end of it all, there is no right or wrong, black or white, when it comes to the supernatural. Experts can try to define it, but what it comes down to is simple. When people die, sometimes their spirits hang around. Why? No one can ever know that for sure until he becomes a spirit himself. Perhaps it is unfinished business, perhaps they do not know that they are dead or perhaps they are just so comfortable where they are that they do not care to move and no one can make them.

The world of the paranormal will continue to enthrall the masses indefinitely because there will never be a clear answer to any of our questions. But is that not really the basis for the fascination of it? We all want to explain the unexplained, even when we know there never will be an explanation. So in the meantime, we go along with our cameras, our recorders and our open minds, hoping to catch a glimpse of the world on the other side. I, for one, enjoy the ride, and I love the thrill of never knowing what mystery may be lurking just around the next corner.

BIBLIOGRAPHY

Albuquerque Journal. "Jesse James Lived to Old Age, Relative Says." October 30, 1983.

Baker, Oran C. "Former Sheriff of Hood County Thinks Real Jesse James Died in Granbury." *Hood County News-Tablet*, August 11, 1966.

Bates, Finis L. *The Escape and Suicide of John Wilkes Booth.* Memphis, TN: J.L. Nichols, 1907.

Enlow, Roger. "A Closer Look." *Hood County News*, December 3, 1994.

Ford, Gary D. "Ghosts and Granbury." *Southern Living Magazine*, October 1998.

Granbury Convention and Visitors Bureau. "History of Granbury." http://granburytx.com/index.aspx?nid=77 (accessed October 14, 2013).

Granbury, Texas Official Website. "Brigadier General Hiram B. Granbury." http://www.granbury.org/index.aspx?NID=703 (accessed October 9, 2013).

———. "Granbury Historic Landmarks." http://www.granbury.org/index.aspx?NID=582 (accessed October 10, 2013).

Hood County Historical Society. "A Historical Tour Around the Square." http://hctxhs.org/articles/square.htm (accessed October 10, 2013).

———. "Historic Markers of Hood County." http://hctxhs.org/articles/markers.htm (accessed October 3, 2013).

———. "Museums of Hood County: The Old Jail Museum." http://hctxhs.org/Museums/jail.htm (accessed October 15, 2013).

Hood County News. "Hood County Rich in History, Folklore." 2012–13 Granbury Visitors Guide. May 2012.

Hood County Texas Genealogical Society. "Biographical Note: William Henry Holland. Owner of Arm Buried in Granbury Cemetery." http://www.granburydepot.org/z/biog/holland.htm (accessed October 10, 2013).

———. "Elizabeth Crockett—Hood County Pioneer. Compiled by Kenneth Hendricks." http://www.granburydepot.org/z/biog/elizabet.htm (accessed October 10, 2013).

———. "The Historical Hanging Tree Controversy." http://www.granburydepot.org/hale/HangingTree.htm (accessed October 15, 2013).

———. "History of Granbury by Mary Kate Durham 1994." http://www.granburydepot.org/z/biog/history.htm (accessed October 3, 2013).

———. "Nelson A. 'Cooney' Mitchell 1796–1875. Only Man Ever Legally Hanged in Hood County." http://www.granburydepot.org/z/biog/cooney.htm (accessed October 15, 2013).

———. "Remember the Crocketts." http://www.granbury.org/z/biog/CrockettRemember.htm (accessed October 10, 2013).

———. "The Story of Cooney Mitchell." http://www.granburydepot.org/z/biog2/MitchellNelson.htm (accessed October 15, 2013).

Jordan, Bobbie. "The Old Jail Ghost." *Hood County News*, October 31, 2000.

Kendall, Pete. "Anna the Friendly Ghost." *Hood County News*, June 27, 2007.

Roddy, Dennis. "Granbury, Texas: Where the Dead Go to Be Buried." *Pittsburgh Post-Gazette*, September 2, 2000.

Saltarelli, Mary. *Historic Hood County: An Illustrated History*. San Antonio, TX: Historical Publishing Network, 2009.

Smith, Kathy. "Granbury's Preservation Leader Dies." *Hood County News*, February 1, 2001.

True Ghost Tales. "The Six Types of Haunting Activities." http://www.trueghosttales.com/types-hauntings.php (accessed October 17, 2013).

About the Author

B randy Herr is the co-founder of the Granbury Ghosts and Legends Tour. Born and reared in Euless, Texas, a suburb of Dallas, Brandy graduated from Trinity High School in 2001 before moving on to graduate from Pennsylvania State University with a bachelor's degree in public relations and a minor in theater in 2005. Brandy has always had a love of history, especially the spookier and more sordid side. She has been the guest on numerous Internet shows and podcasts related to the supernatural, and the Granbury Ghosts and Legends Tour has been featured on several television news programs. Brandy is also the co-host of the annual Granbury Paranormal Expo, which brings together experts and enthusiasts of all ranges of the unexplained. She is proud to now call Granbury her home and wants to share with others the fascinating secrets this small town holds. She currently lives with her husband, Matthew Herr; their two rescued cats, Emma and Goblin; and their rescued dog, Pillow.